Geometric Patterns

Geometrische Muster | Motivi geometrici
Motifs géométriques | Геометрические узоры
Padrões geométricos | 幾何学模様
几何图案 | Patrones geométricos

The Pepin Press
Agile Rabbit Editions

Amsterdam
Singapore

For permission to use images in this book and
CD-ROM, please contact the publishers. Unauthorized use will
be subject to legal proceedings, and the charging of all costs
involved and a penalty.

The Pepin Press BV
P.O. Box 10349
1001 EH Amsterdam
The Netherlands

T +31 20 420 20 21
F +31 20 420 11 52
mail@pepinpress.com
www.pepinpress.com

All images in this book are from
The Pepin Press image archive.

Series Editor **Pepin van Roojen**
Layout **Maria da Gandra & Maaike van Neck**
Image restoration **Jakob Hronek & Kirsten Quast**
Production co-ordinator **Kevin Haworth**

ISBN 978-90-5768-108-0

2015 14 13 12 11 10 09
10 9 8 7 6 5 4 3 2 1

Manufactured in Singapore

Contents

CD and Image Rights

The images in this book are stored on the accompanying CD and can be used for inspiration or as a design resource. The files on Pepin Press CDs are sufficiently large for most applications and the file names correspond with the page and/or image numbers in the book. Larger and/or vector files are available for many images and can be ordered from The Pepin Press.

If you bought this book, you can freely use the images on the CD for:
• all private, non-professional and non-commercial endeavours;
• web design using 10 or fewer images per project and/or
• small-scale commercial use (for example: brochures with a print run of fewer than 5000 copies in which not more than 5 of our are used).

Permission is required for the use of the images:
• in other publications,
• for large-scale commercial use,
• for the decoration of luxury goods and/or
• in major advertising campaigns.

If in doubt, please contact us. Our permission policy is very reasonable and fees charged, if any, tend to be minimal. In any event, we welcome examples of work in which our images have been used.

Further distribution of Pepin Press' material in any form and by any means is prohibited.

For inquiries about permissions and fees, please contact:
mail@pepinpress.com
Fax +31 20 4201152

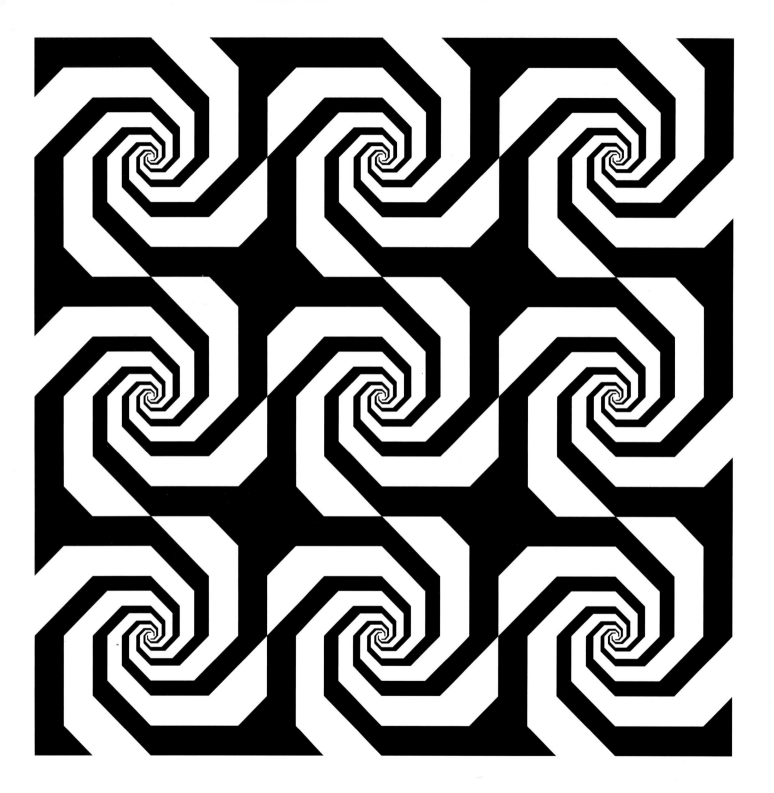

4

CD y derechos de las imágenes

Las imágenes que contiene este libro están incluidas en el CD adjunto y pueden utilizarse como inspiración o referencia para el diseño. Los archivos incluidos en los CD de The Pepin Press tienen un tamaño suficiente para la mayoría de las aplicaciones, y los nombres de archivo se corresponden con los números de página o de imagen utilizados en el libro. Para muchas de las imágenes hay disponibles archivos más grandes o archivos vectoriales, que pueden encargarse a The Pepin Press.

Si ha comprado este libro, puede utilizar libremente las imágenes incluidas en el CD para:
• cualquier propósito particular, no profesional y no comercial;
• diseño web, siempre que utilice un máximo de 10 imágenes por proyecto;
• uso comercial de poca envergadura (por ejemplo, folletos con una tirada inferior a los 5.000 ejemplares en los que no se usen más de cinco imágenes nuestras).

Se necesita autorización para la utilización de las imágenes:
• en otras publicaciones;
• para un uso comercial de amplia difusión;
• para la decoración de artículos de lujo;
• en campañas publicitarias importantes.

En caso de duda, le rogamos que se ponga en contacto con nosotros. Nuestra política de autorización es muy razonable y, en los casos en que se aplican tarifas, estas tienden a ser mínimas. En cualquier caso, agradecemos que nos envíen ejemplos de trabajos en los que se hayan utilizado nuestras imágenes.

Queda prohibida toda distribución de material de The Pepin Press que exceda de cualquier modo los límites mencionados.

Para consultas sobre autorizaciones y tarifas, póngase en contacto con:
mail@pepinpress.com
Fax +31 20 4201152

CD und Bildrechte

Alle Abbildungen in diesem Buch sind auf der beigelegten CD gespeichert und können als Anregung oder Ausgangs-material für Designzwecke genutzt werden. Alle Bilddateien auf den CDs von Pepin Press sind so groß dimensioniert, dass sie für die meisten Anwendungszwecke ausreichen. Die Namen der einzelnen Bilddateien auf der CD entsprechen den Seitenzahlen und/oder den Bildzahlen im Buch. Auf Anfrage können Dateien und/oder Vektordateien der meisten Bilder bei The Pepin Press bestellt werden.

Als Käufer dieses Buchs dürfen Sie die Bilder auf der CD kosten-frei nutzen für:
• sämtliche privaten, nicht professionellen und nicht-kommer-ziellen Anwendungen
• zum Zweck des Webdesign (bis max. 10 Bilder pro Projekt) und/oder
• für kommerzielle Zwecke in kleinem Rahmen (z.B. Broschüren mit einer Druckauflage von max. 5.000 Exemplaren bei einer Nutzung von max. 5 Bildern aus diesem Buch)

Dagegen muss eine Genehmigung eingeholt werden bei der Nutzung der Bilder:
• in anderen Publikationen
• für kommerzielle Zwecke in großem Rahmen
• zur Dekoration von Luxusgütern und/oder
• in Werbekampagnen

In Zweifelsfällen bitten wir Sie, uns zu kontaktieren: Im Normal-fall erteilen wir solche Genehmigungen recht großzügig und erheben - wenn überhaupt - nur geringe Gebühren. In jedem Fall freuen wir uns über Arbeitsproben, in denen unser Bild-material verwendet wurde.

Darüber hinaus ist jede weitere Verbreitung von Pepin Press-Materialien in jeglicher Form, Art und Weise untersagt.

Für weitere Informationen über Genehmigungen und Gebühren wenden Sie sich bitte an:
mail@pepinpress.com
Fax: +31 20 4201152

5

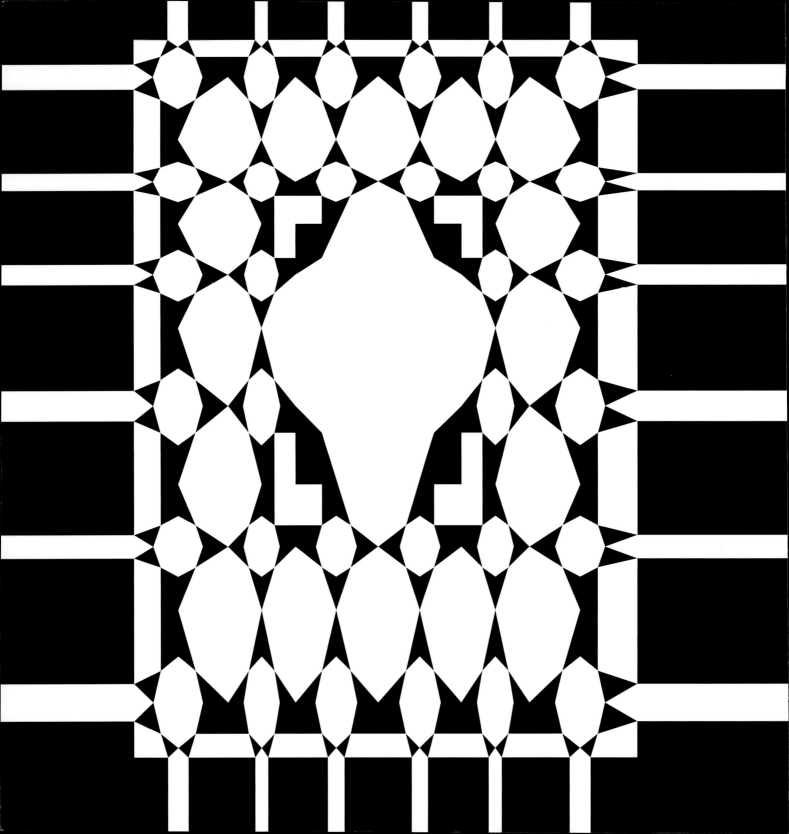

O CD e direitos sobre as imagens

As imagens deste livro estão guardadas no CD que o acompanha e podem ser usadas para inspiração ou como recurso de design. Os ficheiros dos CDs da The Pepin Press são suficientemente grandes para a maioria das aplicações e os nomes dos ficheiros correspondem às páginas e/ou aos números das imagens do livro. Para muitas das imagens estão disponíveis ficheiros maiores e/ou vectoriais, que podem ser encomendados à The Pepin Press.

Se comprou este livro, pode usar livremente as imagens do CD para:
• todas as aplicações pessoais, não-profissionais e não-comerciais;
• web design com um máximo de 10 imagens por projecto; e/ou
• utilizações comerciais de pequena escala (por exemplo: brochuras com uma tiragem de impressão de menos de 5.000 cópias em que não sejam usadas mais de 5 das nossas imagens).

Será necessária autorização para a utilização das imagens:
• noutras publicações;
• em aplicações comerciais de grande escala;
• na decoração de artigos de luxo; e/ou
• em grandes campanhas publicitárias.

Em caso de dúvida, contacte-nos. A nossa política de autorizações é muito razoável e o custo debitado, se existir, tende a ser reduzido. Em qualquer caso, recebemos de bom grado exemplos de obras nas quais as nossas imagens tenham sido usadas.

Para além disso, é proibida a distribuição de materiais da The Pepin Press em qualquer forma e por qualquer meio.

Para questões acerca de autorizações e custos, contacte:
mail@pepinpress.com
Fax +31 20 4201152

CD et droits relatifs aux images

Les images de ce livre sont également incluses dans le CD qui l'accompagne et sont exploitables comme source d'inspiration ou de base à un document. Les fichiers contenus sur les CD de The Pepin Press sont de taille suffisamment grande pour convenir à la plupart des usages et le nom des fichiers correspond au numéro des pages et/ou des images du livre. De nombreuses illustrations sont proposées sous forme de fichiers de taille plus importante et/ou vectorisées, que vous pouvez commander auprès de The Pepin Press.

Si vous avez acheté ce livre, vous pouvez utiliser à titre gratuit les images contenues dans le CD pour :
• tous les usages privés, non professionnels et non commerciaux ;
• la réalisation de sites Web utilisant au maximum 10 images par site et/ou ;
• les usages commerciaux de type artisanal (par exemple : brochures tirées à moins de 5 000 exemplaires et reprenant au plus 5 images).

Une autorisation est nécessaire pour l'utilisation des images :
• dans d'autres publications ;
• pour un usage commercial de grande envergure ;
• pour la décoration d'articles de luxe et/ou ;
• dans le cadre de campagnes publicitaires à grande diffusion.

En cas de doute, veuillez nous contacter. Notre politique d'autorisation est très accommodante et nos frais pratiqués, le cas échéant, sont minimes. Dans tous les cas, nous sommes intéressés de recevoir des exemples de mises en œuvre de nos images.

Toute autre distribution de documents de The Pepin Press sous quelque forme et par quelque moyen que ce soit est interdite.

Pour toute demande de renseignements sur les autorisations et les frais, veuillez contacter :
mail@pepinpress.com
Fax : +31 20 4201152

Права на использование изображений и компакт-диска

Изображения из книги хранятся на прилагаемом CD и могут быть использованы как источник вдохновения или в качестве материалов для дизайна. Файлы, содержащиеся на компакт-дисках издательства The Pepin Press, достаточно объемны для широкого применения; названия файлов соответствуют странице и/или номеру изображения в книге. Для многих изображений используются векторные файлы и/или файлы большого размера. Их можно заказать в издательстве The Pepin Press.

В случае покупки данной книги изображения, содержащиеся на прилагаемом компакт-диске, можно свободно использовать в нижеперечисленных случаях:
• для частных, любительских и некоммерческих проектов;
• для разработки веб-сайтов при условии использования не более 10 изображений для каждого проекта;
• для коммерческого использования в небольших масштабах (например: для печати брошюр тиражом, не превышающим 5000 копий, при условии использования не более 5 наших изображений).

В нижеперечисленных случаях для использования изображений требуется разрешение:
• применение в других публикациях;
• для коммерческого использования в большом масштабе;
• при оформлении предметов роскоши;
• использование в крупных рекламных кампаниях.

Свяжитесь с нами, если у вас возникли какие-либо вопросы. Мы придерживаемся весьма приемлемой политики разрешений, а оплата наших услуг минимальна или вовсе отсутствует. Мы всегда рады видеть проекты, в которых были использованы наши изображения.

Распространение материалов издательства The Pepin Press в форме и способами, не оговоренными выше, запрещено.

Чтобы узнать об условиях оплаты и получения разрешения, свяжитесь с нами:
mail@pepinpress.com
Факс: +31 20 4201152

CD及びイメージの著作権について

付録のCDに納められた画像は、デザインの参考にしたり、インスピレーションを得るための材料としてご使用ください。The Pepin PressのCDに収録されているファイルは、ほとんどのアプリケーションに対応できるサイズで、ファイル名は本書のページ番号やイメージ番号に対応しています。より大きなサイズのファイルやベクトルファイルをご希望の方は、The Pepin Press宛てにご連絡ください。

本書をご購入された場合は、CDに収録された画像を次の目的で無料でご利用いただけます。
• 個人的、非営利的、非商業的目的
• 1プロジェクトにつき10点以下の画像を使用するウェブデザイン
• 小規模の商業目的 i例えば、印刷部数5000以下で掲載画像5点以下のパンフレット)。

次の場合は、画像使用の許可が必要です。
• その他の刊行物
• 大規模な商業用途
• 高級嗜好品の装飾目的
• 広範囲にわたる広告キャンペーン。

判断が困難な場合は、ご相談ください。著作権料が必要となる場合でも最小限の料金でご提供させていただきます。どのような使用目的であっても、画像をご使用になったメディアのサンプルをご提供いただけると幸いです。

The Pepin Pressの素材の配布は、いかなる形式や方法でも禁止されております。

使用許可と著作権料については下記にお問い合わせください。
mail@pepinpress.com
ファックス F +31 20 4201152

CD e i diritti delle immagini

Le immagini di questo libro sono riunite nel CD accluso e possono essere usate come fonte d'ispirazione o risorsa grafica. I file contenuti nei CD della Pepin Press possono essere utilizzati nella maggior parte delle applicazioni e i nomi dei file corrispondono ai numeri delle pagine oppure delle immagini del libro. Le dimensioni dei file sui CD-ROM della Pepin Press sono adatte alla maggior parte delle applicazioni. In ogni caso sono disponibili file più grandi o vettoriali che possono essere ordinati alla Pepin Press stessa.

Se avete comprato questo libro, potete utilizzare le immagini contenute nel CD allegato per:
• tutti gli scopi privati, non professionali e non commerciali;
• il web design, se utilizzate 10 o meno di 10 immagini per ogni progetto e/o
• un uso commerciale su scala ridotta (per esempio: depliant con una tiratura inferiore o pari a 5000 copie in cui non vengano usate più di cinque delle nostre immagini).

Dovete chiedere il permesso per usare le immagini:
• in pubblicazioni di altro tipo,
• per un uso commerciale su vasta scala,
• per la decorazione di beni di lusso e/o
• per l'utilizzo in campagne pubblicitarie di aziende di grande rilevanza.

Qualora abbiate dei dubbi, siete pregati di contattarci. Concediamo il permesso all'utilizzo delle nostre immagini in base a regole semplici e ragionevoli, e le tariffe che applichiamo, se le applichiamo, tendono a essere minime. In ogni caso siamo ben lieti di ricevere copie dei lavori in cui sono state impiegate le nostre immagini.

È proibita la distribuzione del materiale della Pepin Press in ogni altra forma e per ogni altro scopo.

Per ricevere ulteriori informazioni sui permessi e le tariffe, per favore contattateci ai seguenti recapiti:
mail@pepinpress.com
Fax +31 20 4201152

CD 光盘及图像的版权

书中载有的图像均存储在附有的 CD 光盘中, 可以用来启发创作灵感, 亦可以用作设计的资源。The Pepin Press 出版的 CD 光盘所载的档案相当庞大, 足以应付多数应用。档案的名称是跟本书的页码及/或图像的编号相对应的。The Pepin Press 亦提供更大及/或矢量格式化的档案, 欢迎选购。

若购买本书, 您可以免费把 CD 光盘所载的图像应用于:
• 一切私人、非专业性及非商业性的用途;
• 网页设计 (以每个设计项目使用 10 个或以下图像为限) 及/或
• 小规模的商业用途 (例如: 印数在 5000 张以下的宣传小册子、并用少于 5 个版权属于本社的 图像)

在下列情况下, 请在使用图像前先取得本社的许可:
• 用于其他刊物,
• 大规模的商业用途,
• 用于装饰奢侈品及/或
• 用于大型的广告项目。

如有任何疑问, 请联系我们。本社订有一套合理的许可政策。若有收费的需要, 涉及的费用通常亦是极低廉的。我们亦十分欢迎读者在使用我们的图像后, 把作品寄来与我们分享。

任何人不得以任何类型及途径在其他情况下使用版权属The Pepin Press 的资源。

有关许可及收费的查询, 请联系:
mail@pepinpress.com
传真: +31 20 4201152

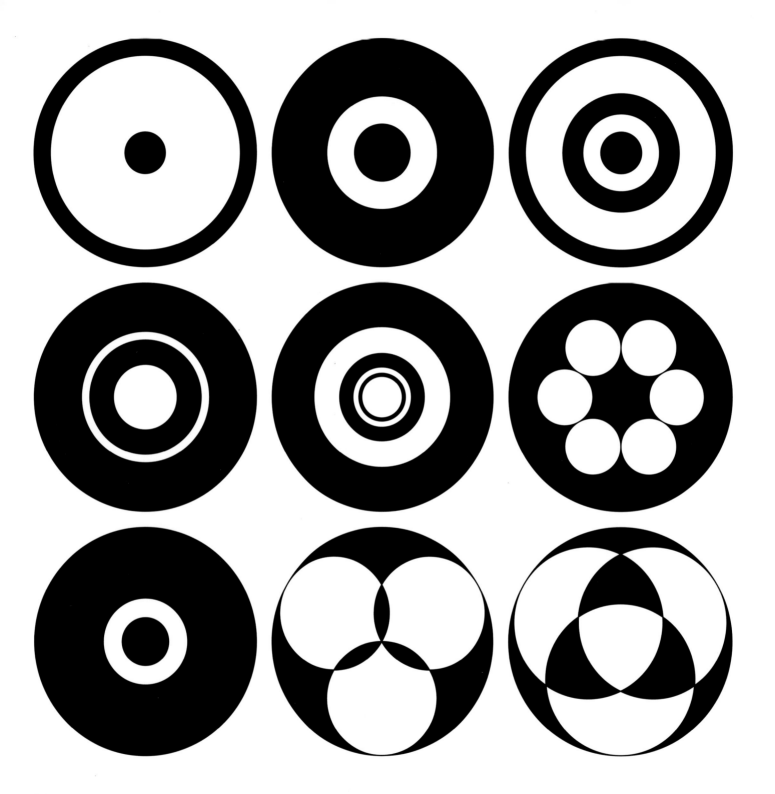

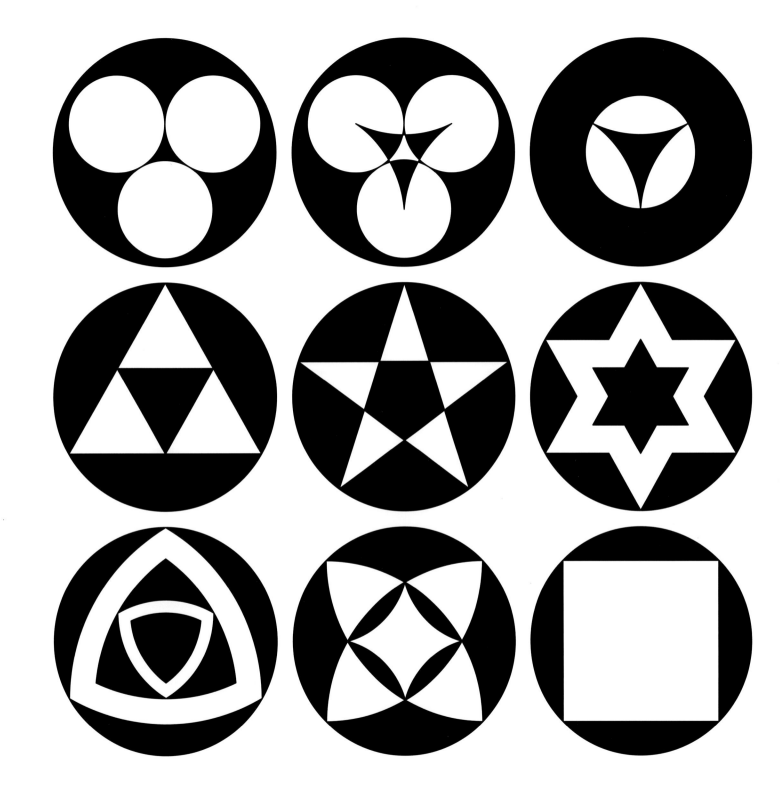

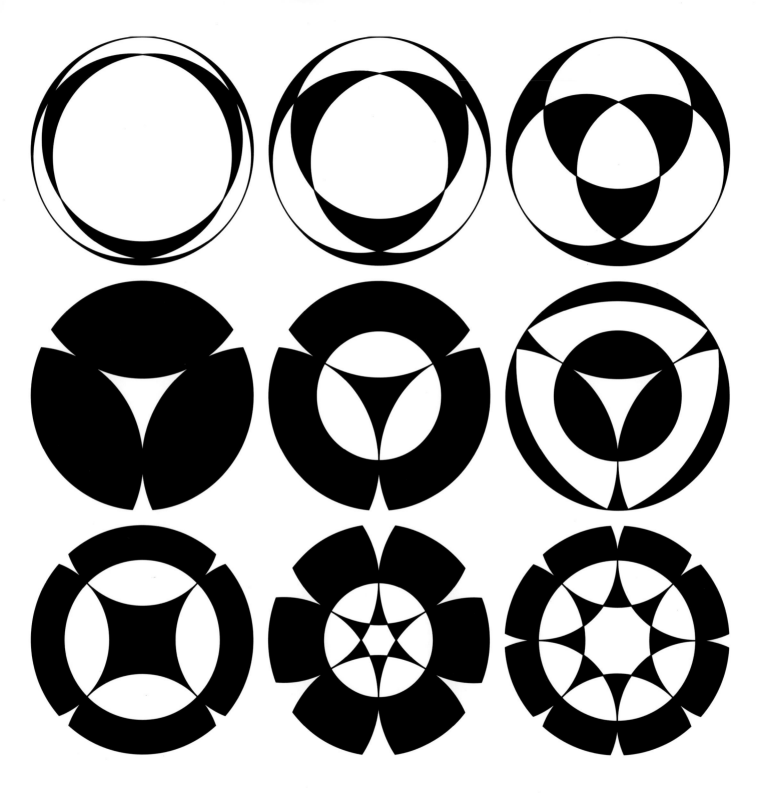

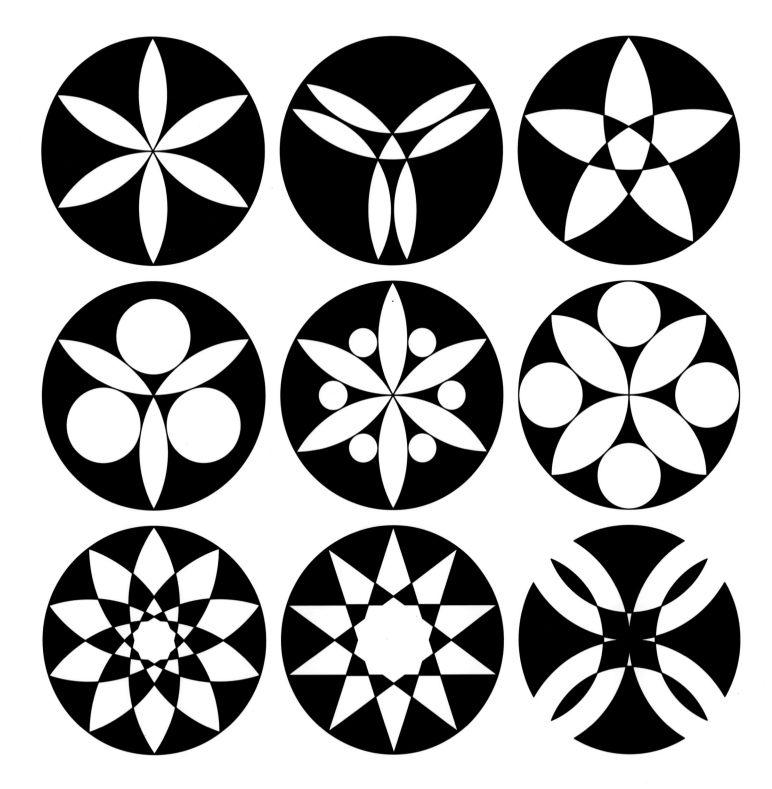

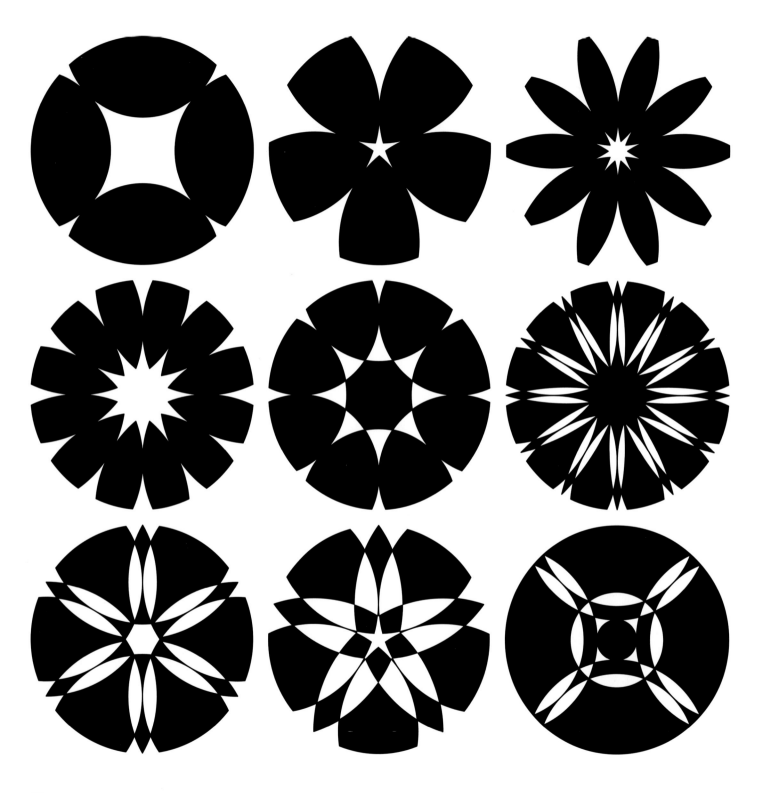

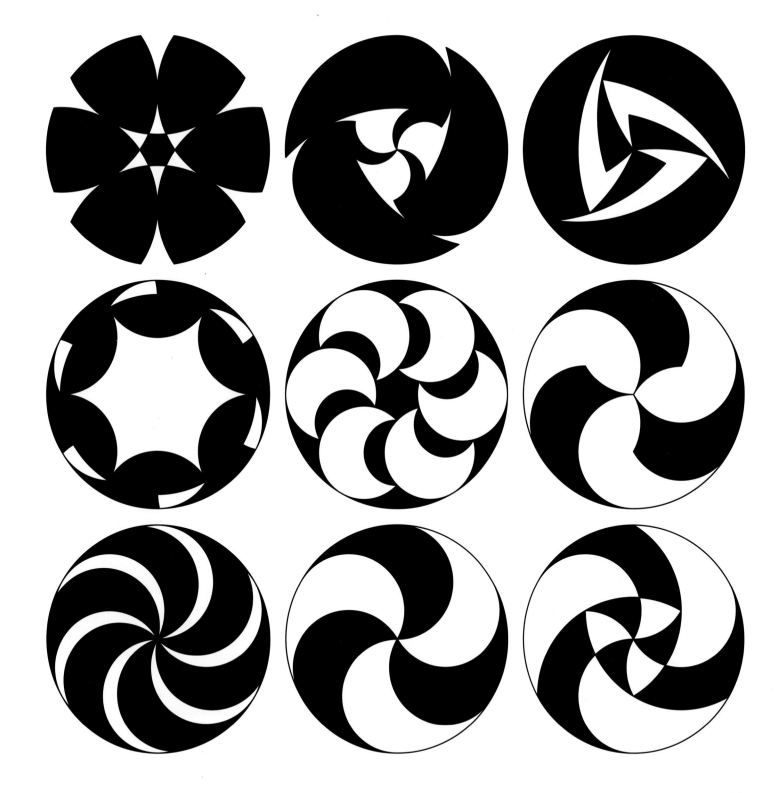

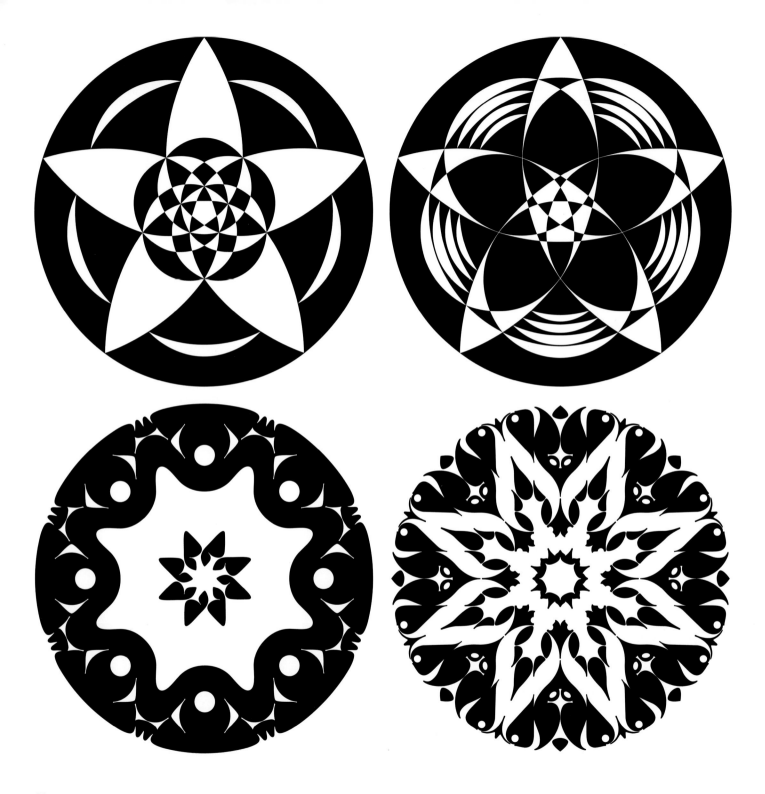

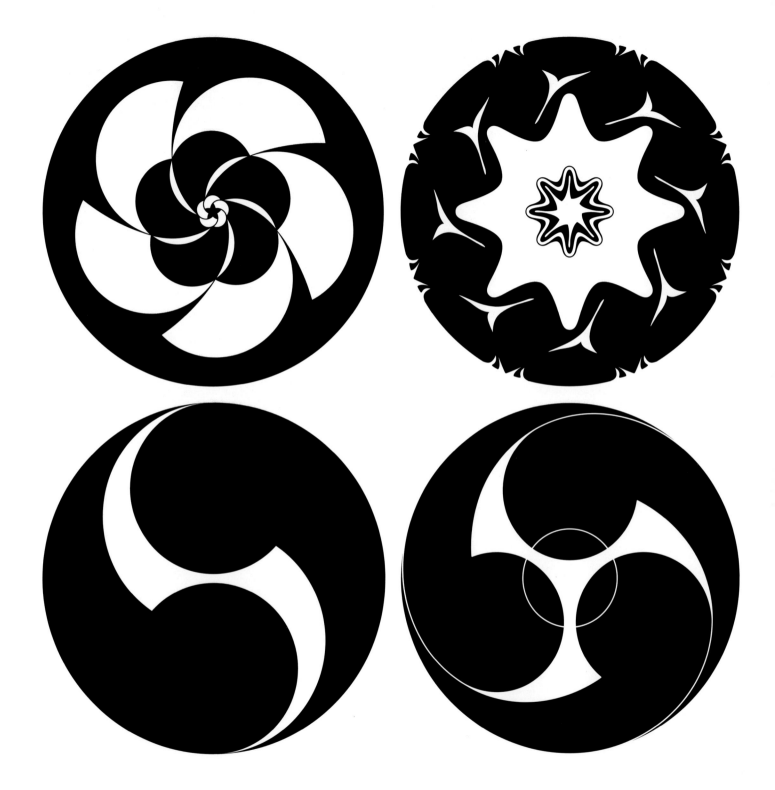

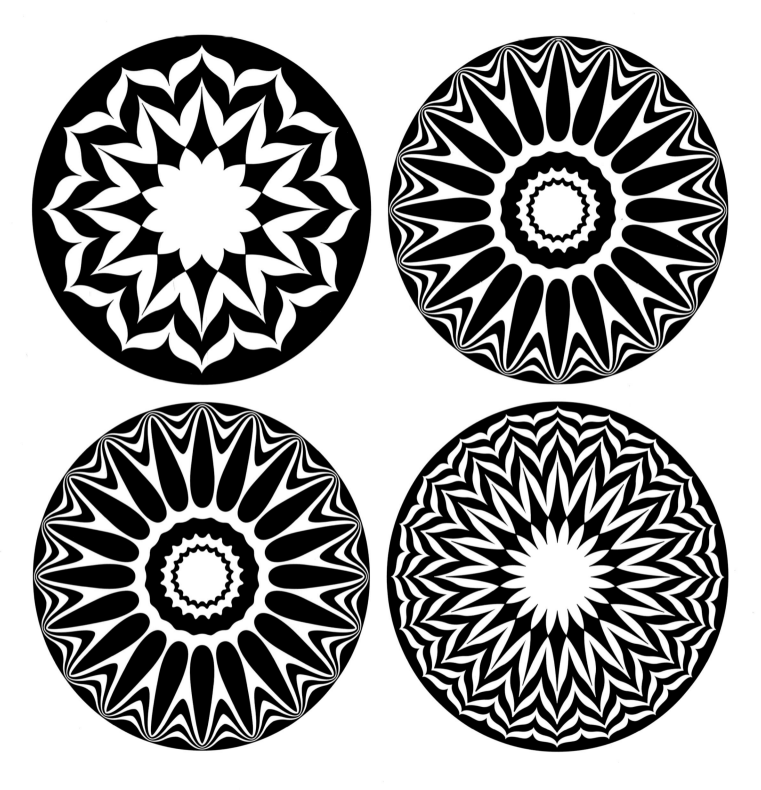

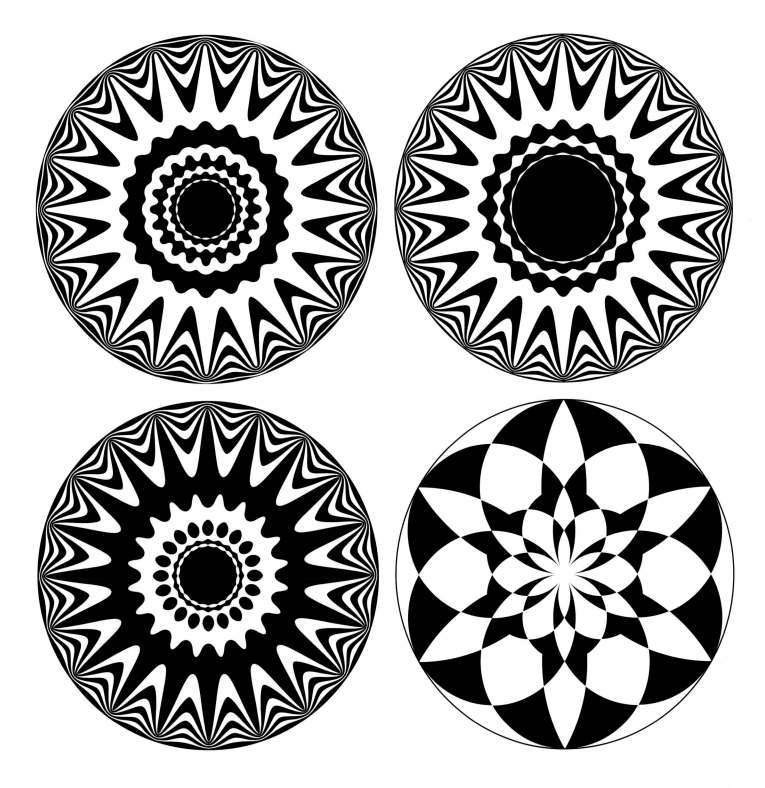

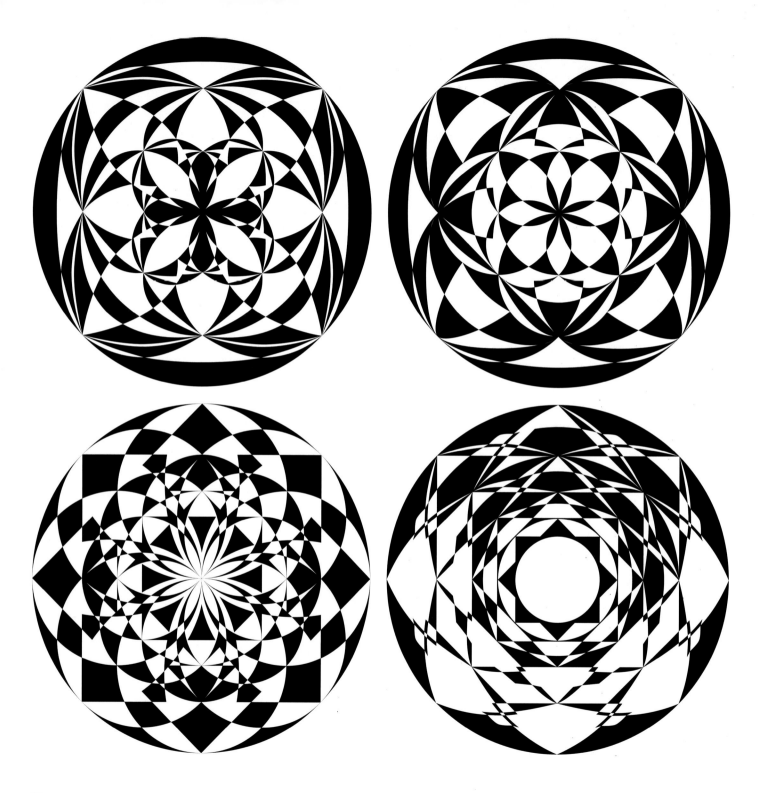

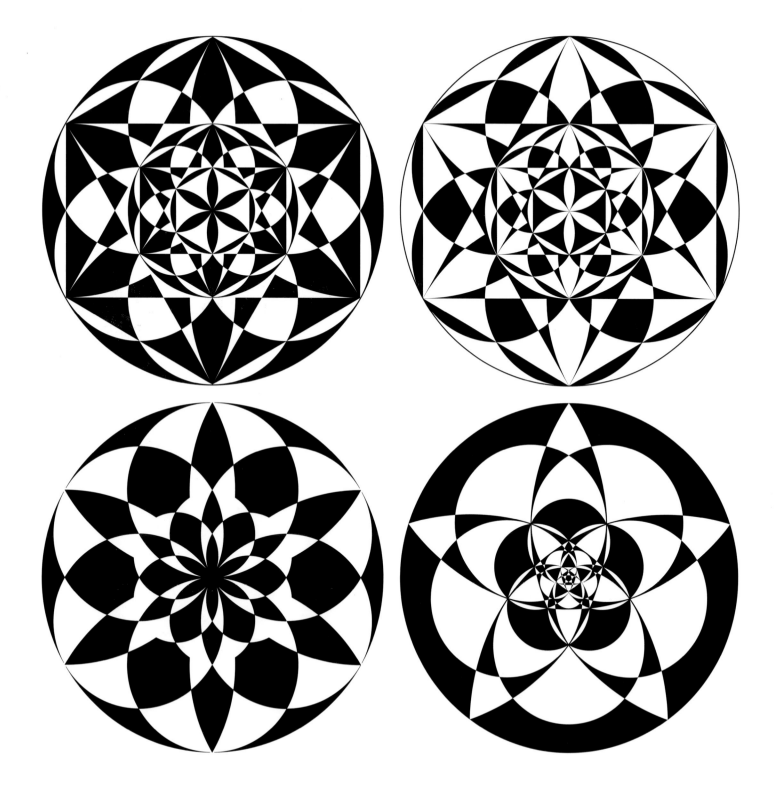

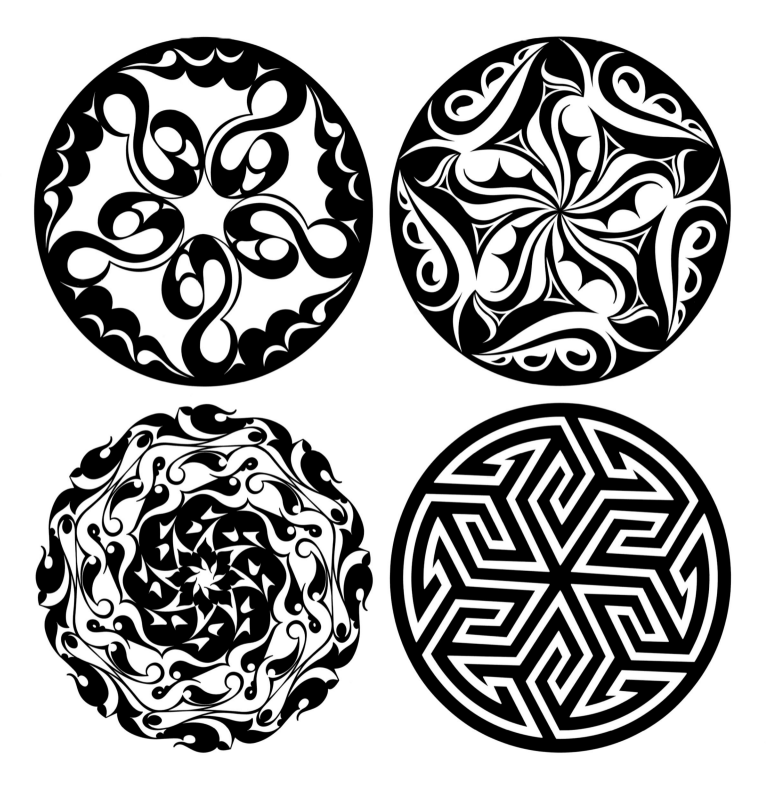

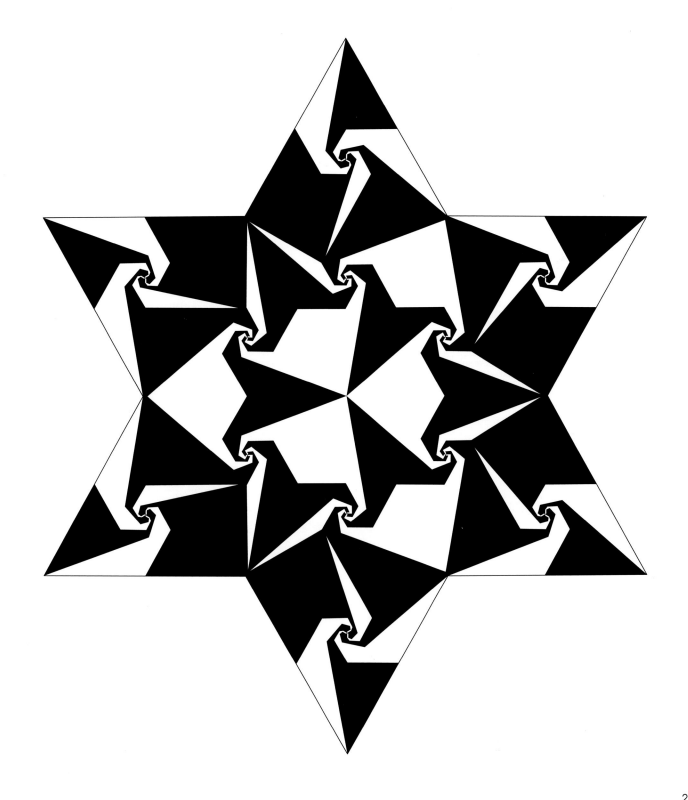

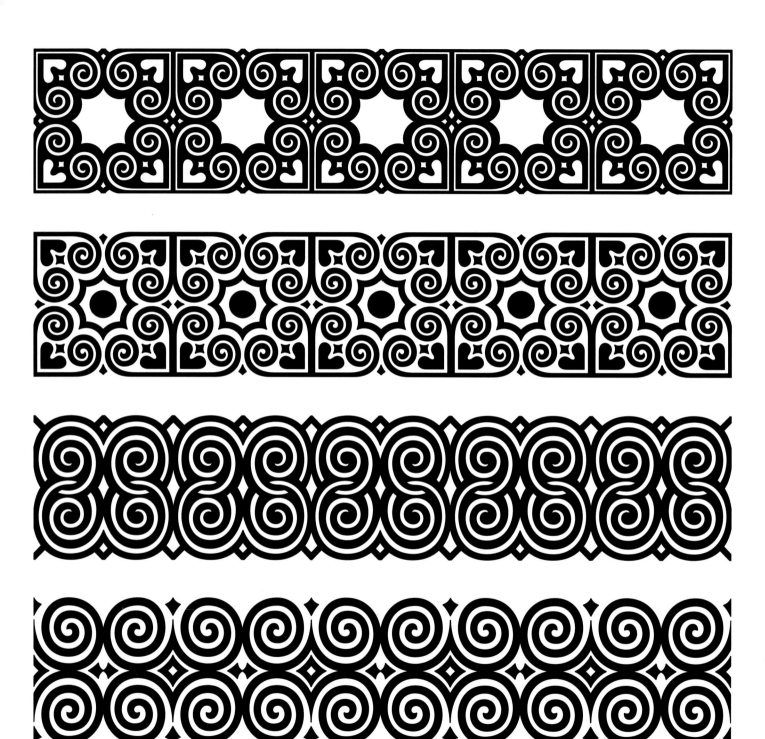

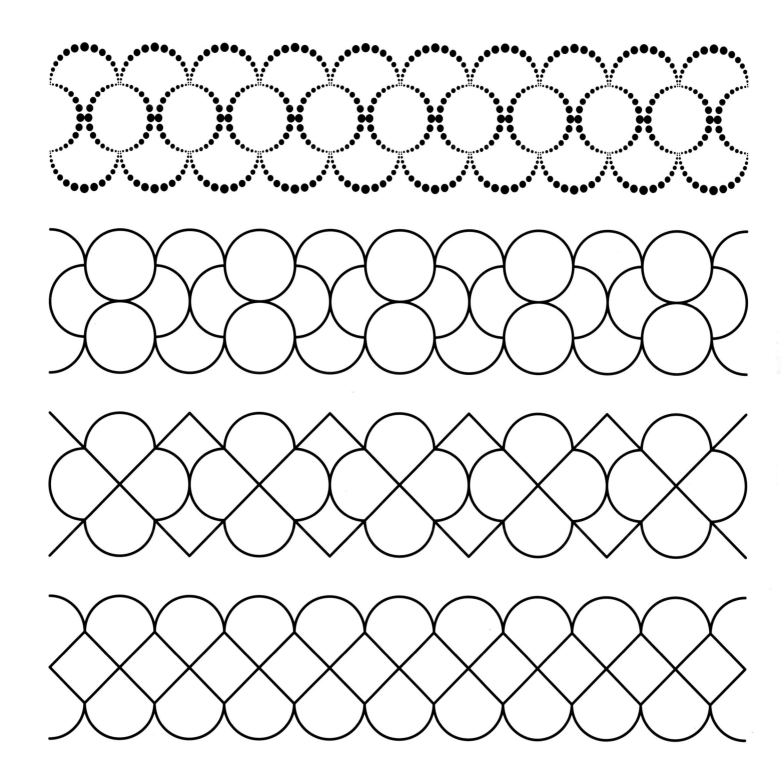

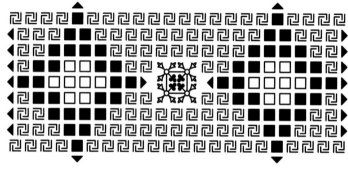
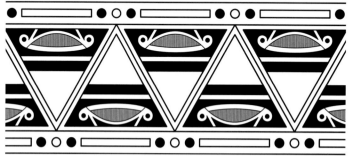
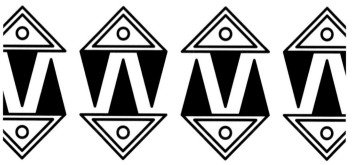
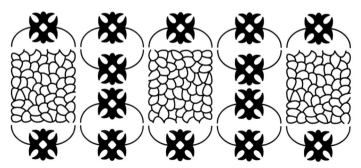

33

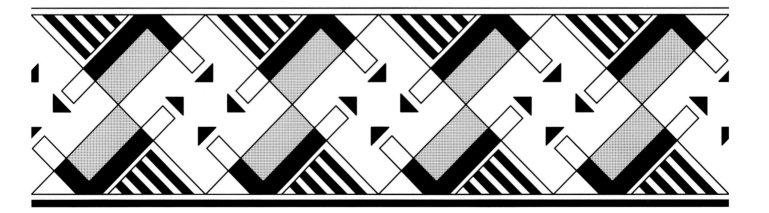

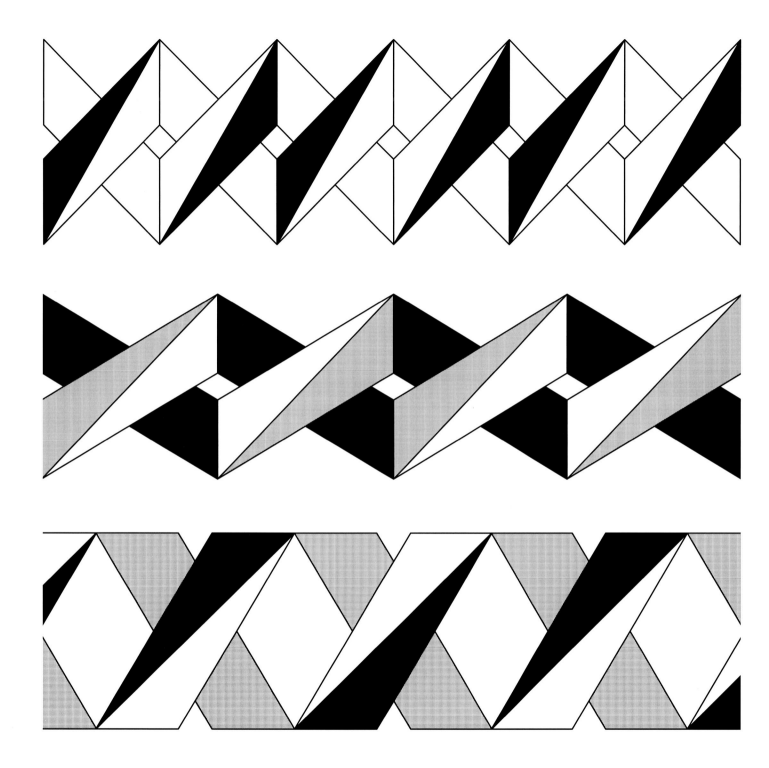

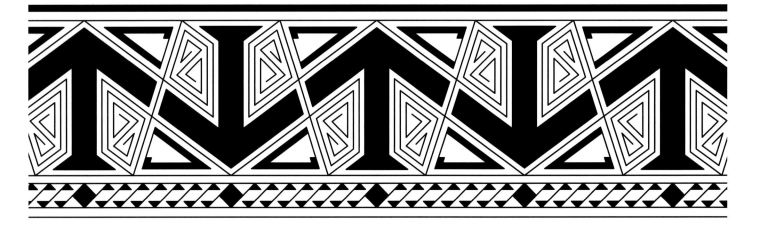

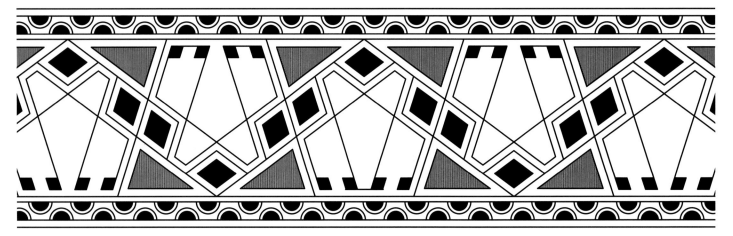

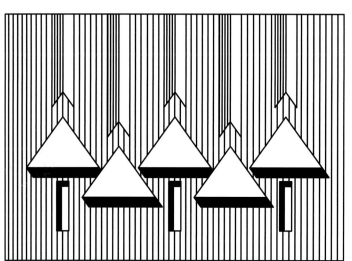
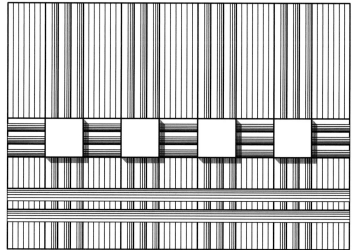

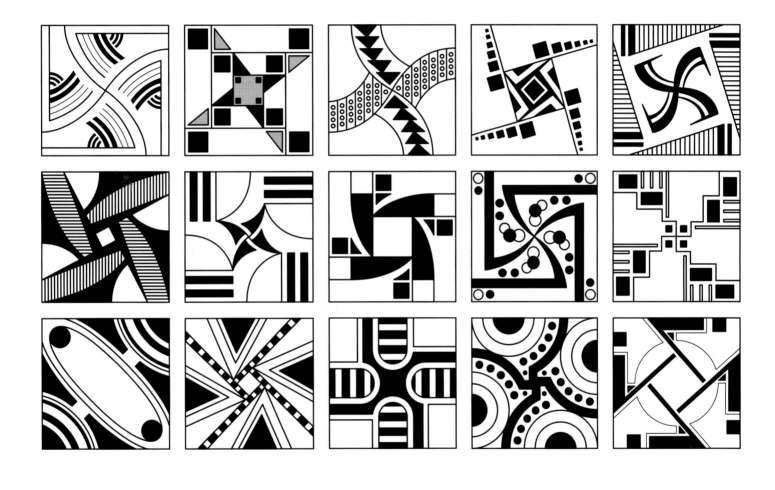

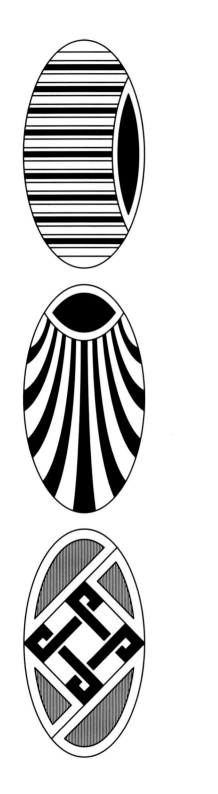
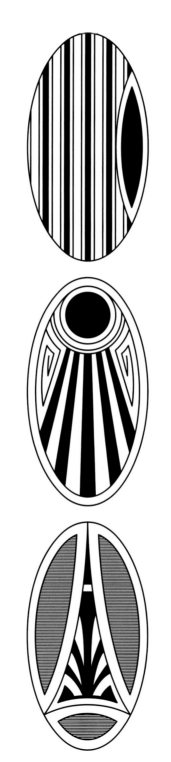
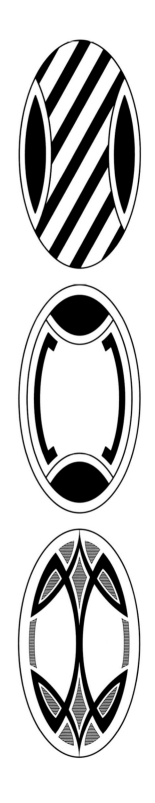

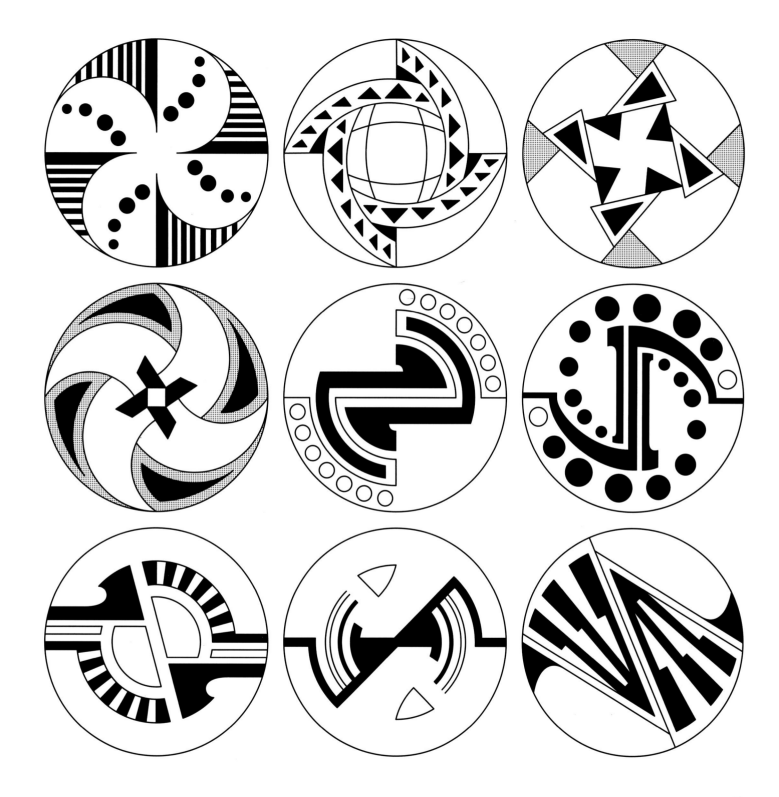

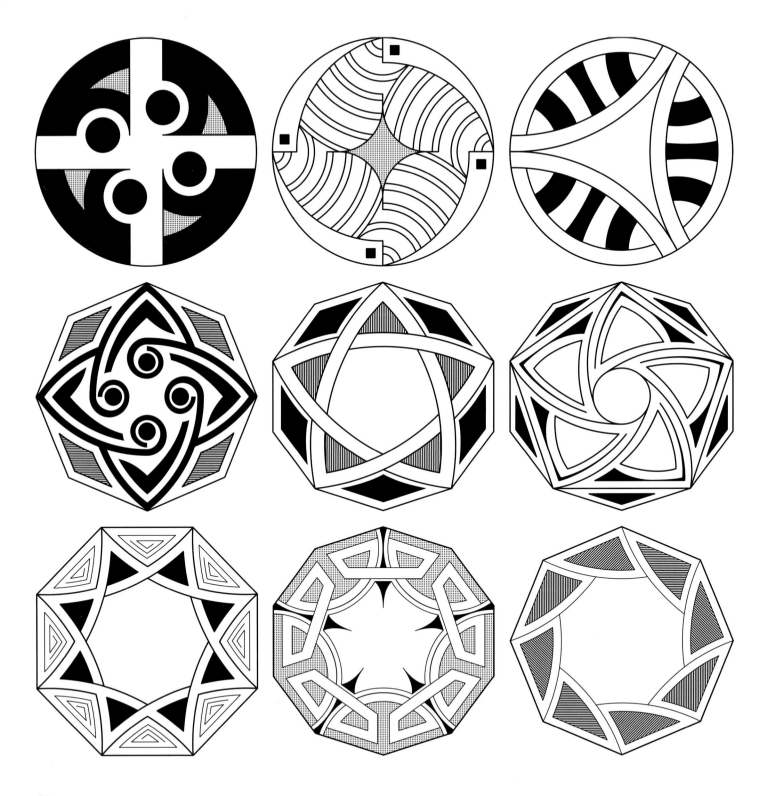

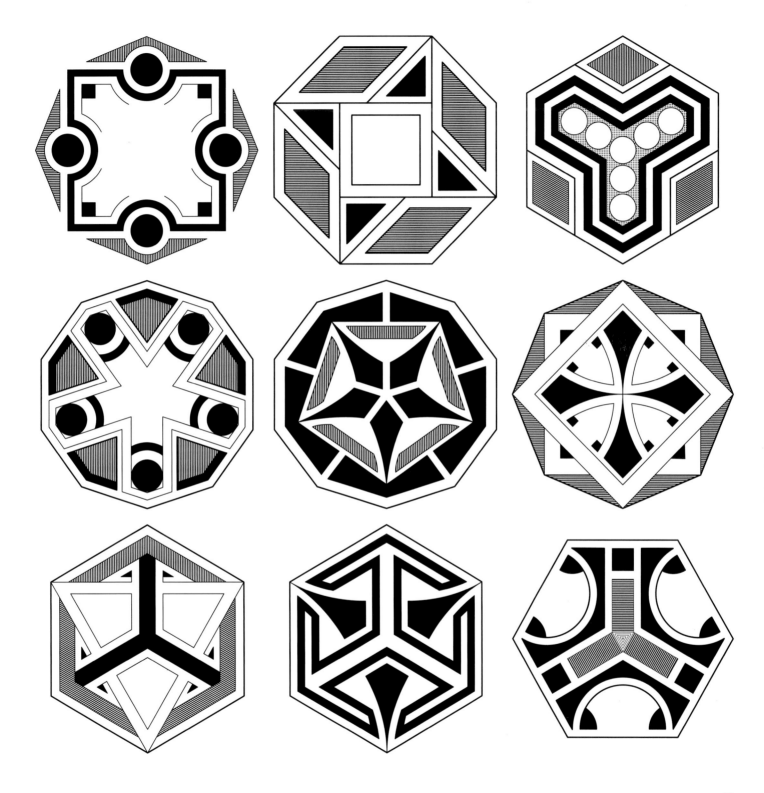

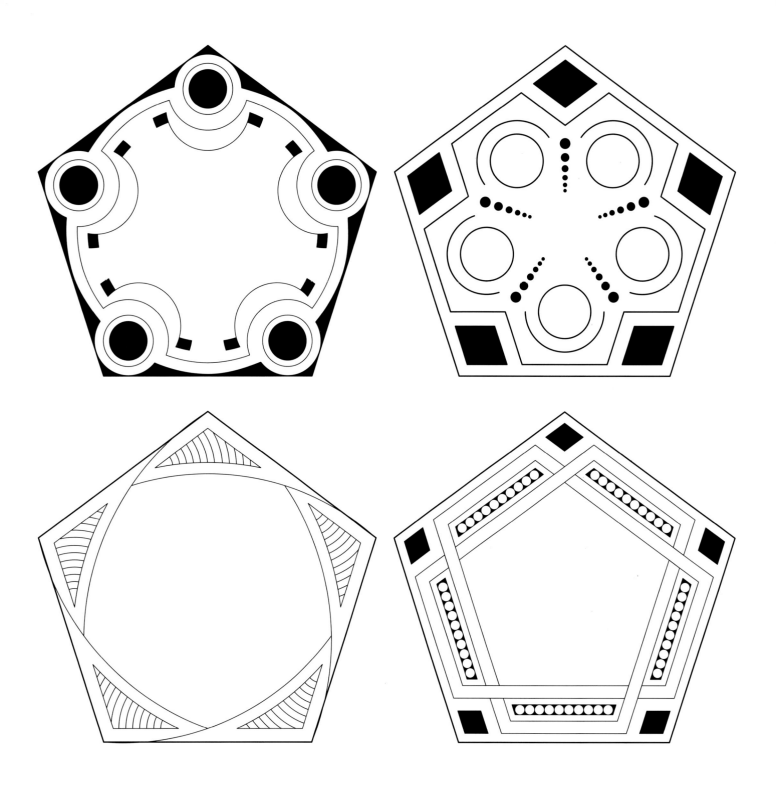

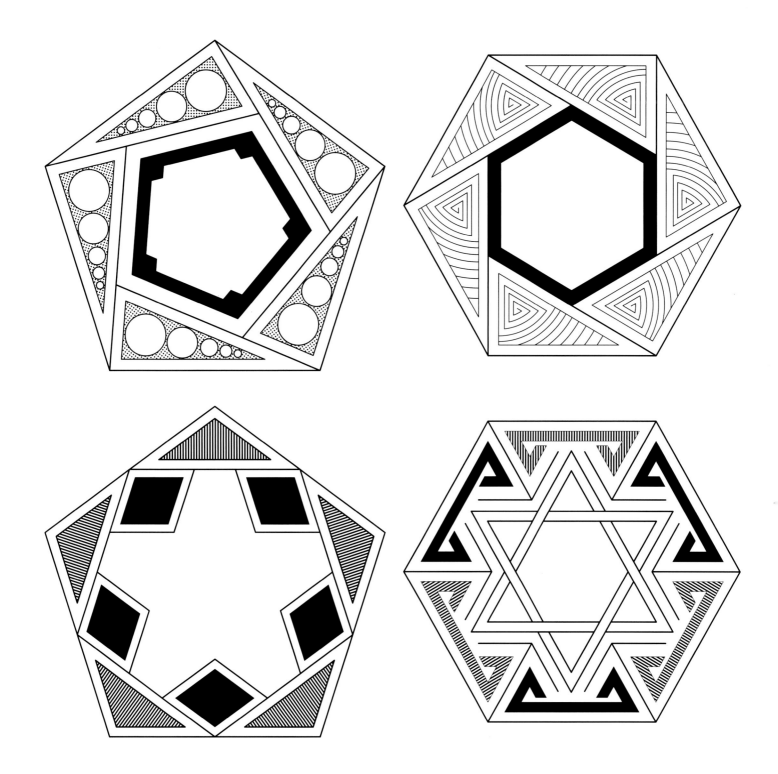

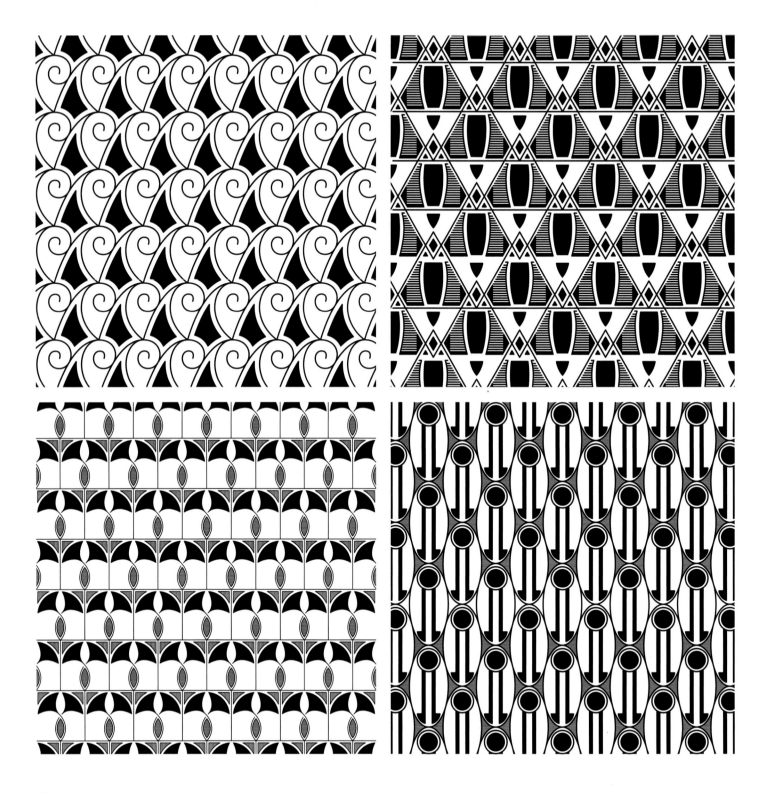

48

50

51

52

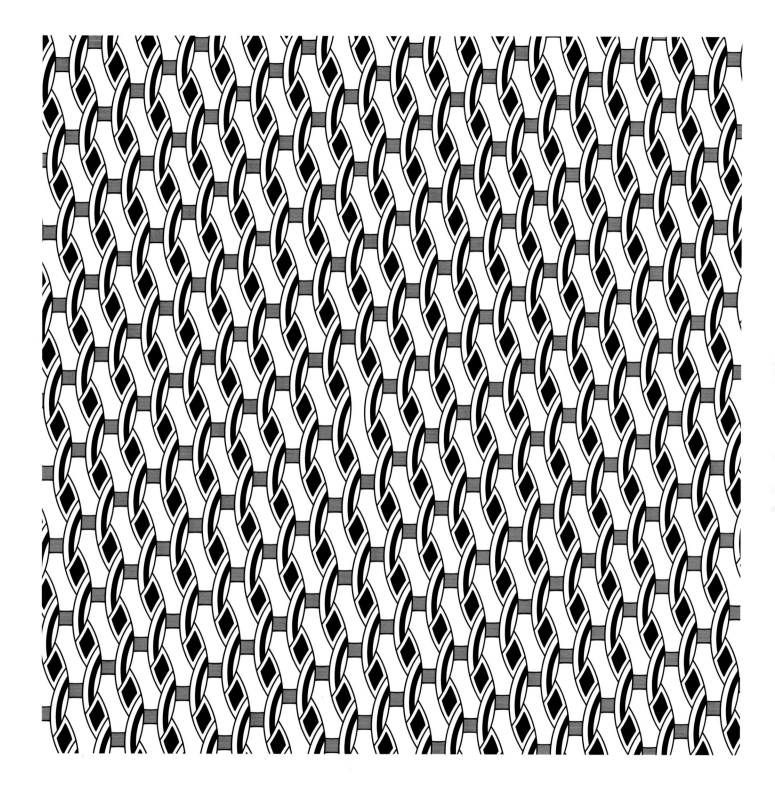

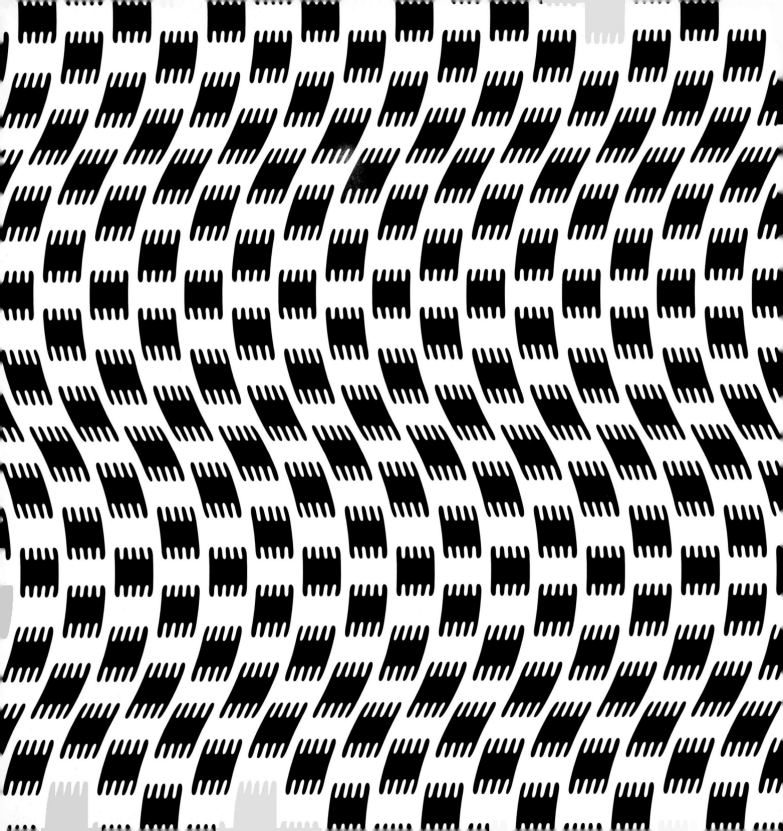

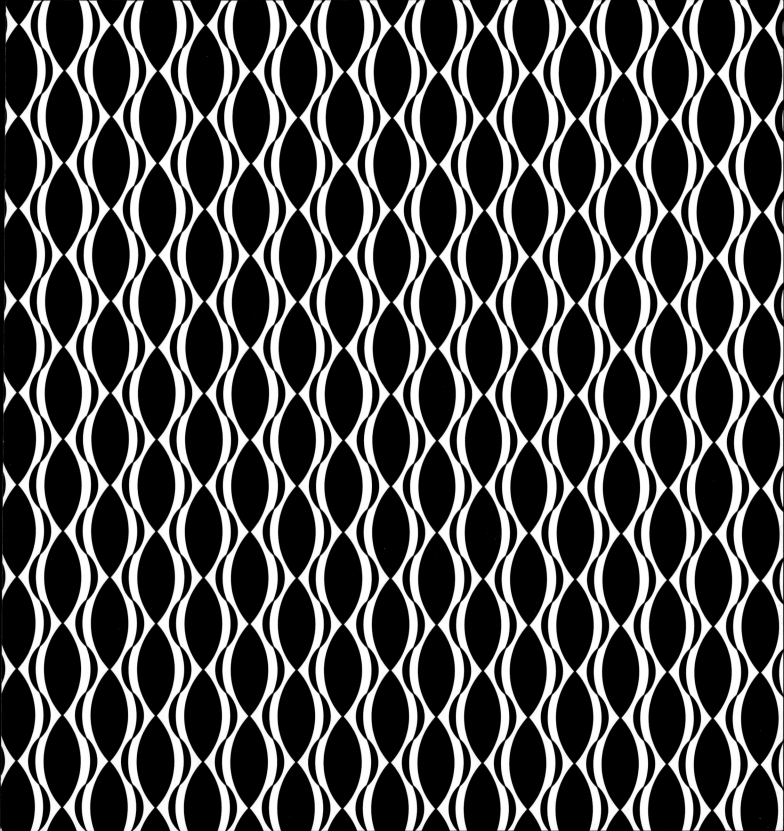

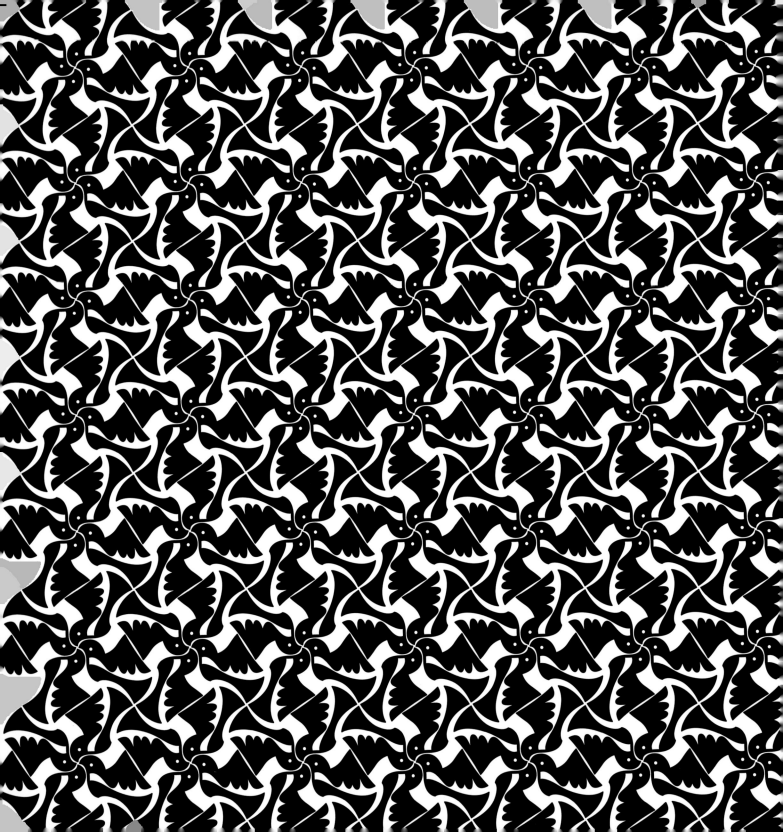

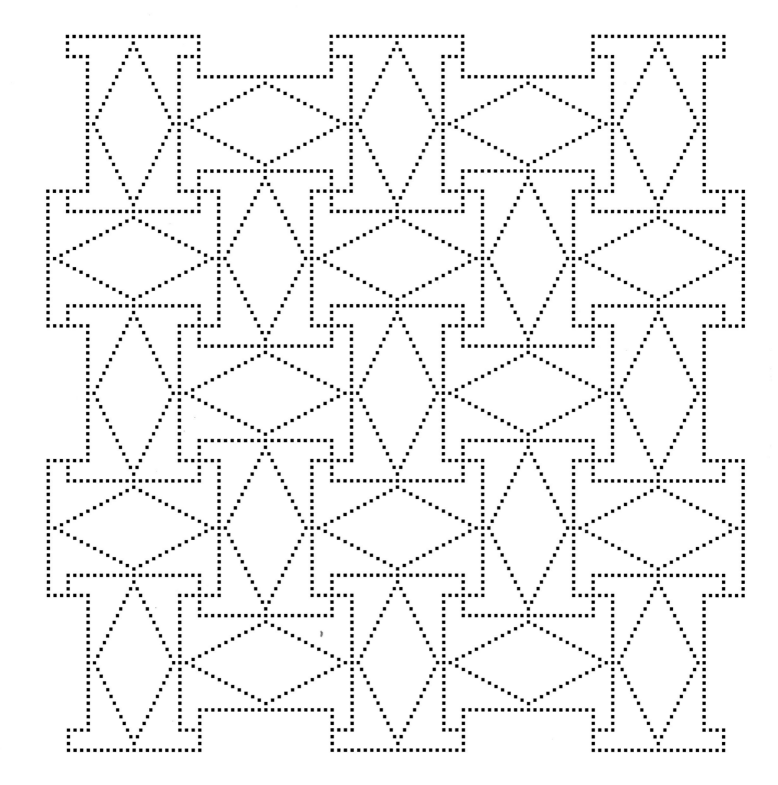

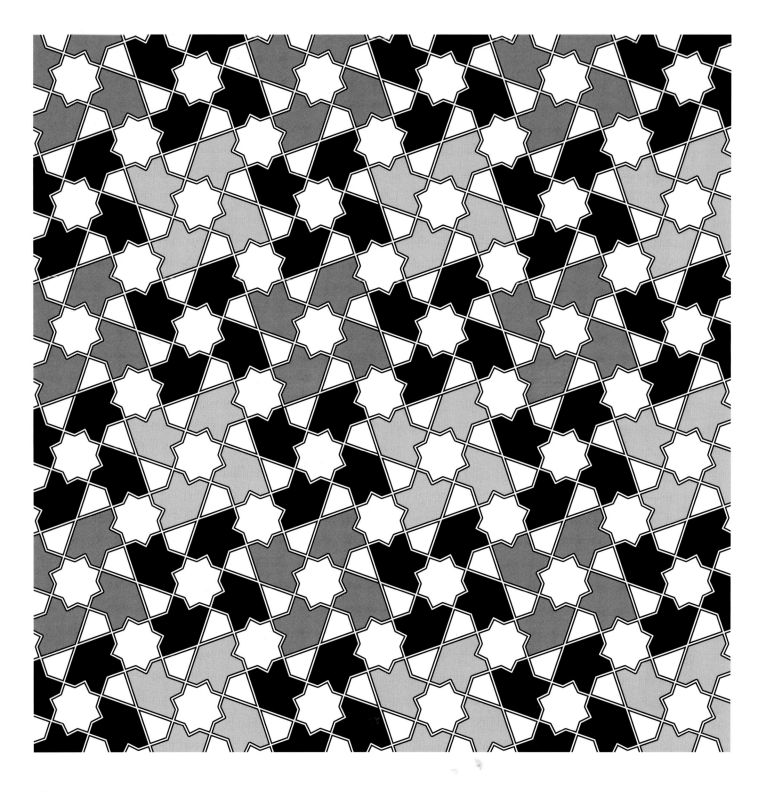

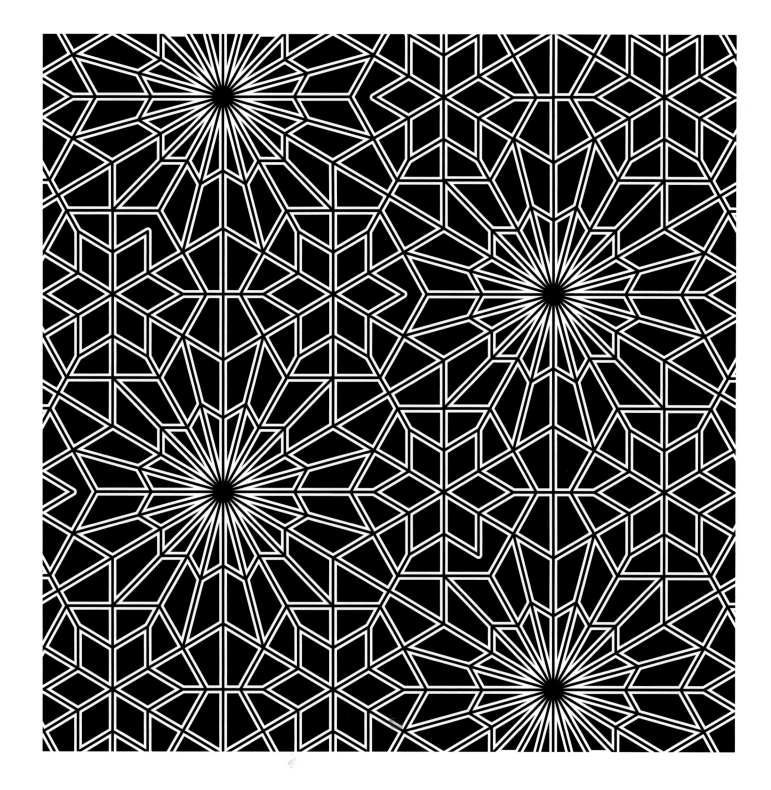

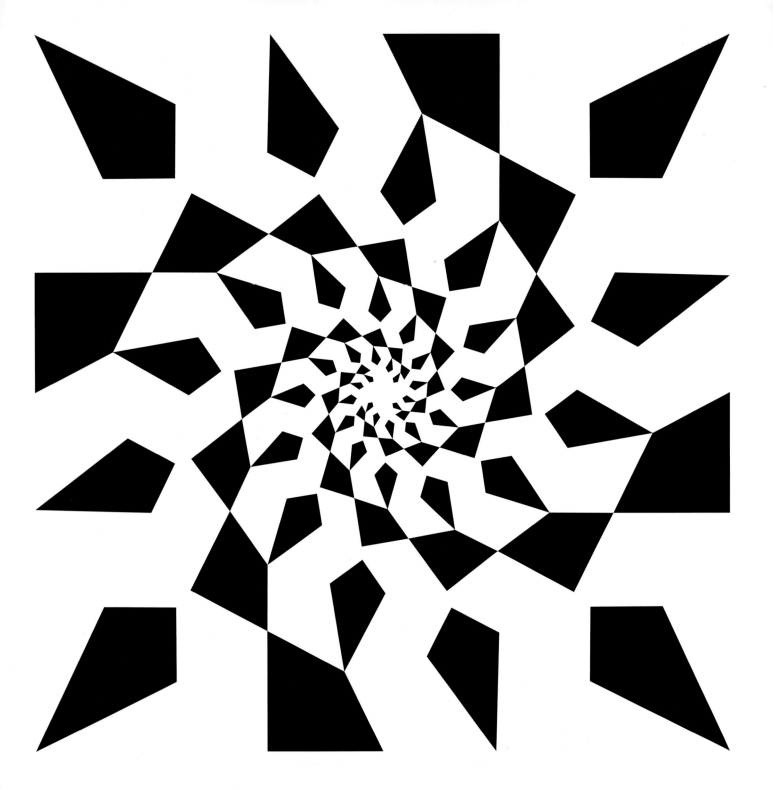

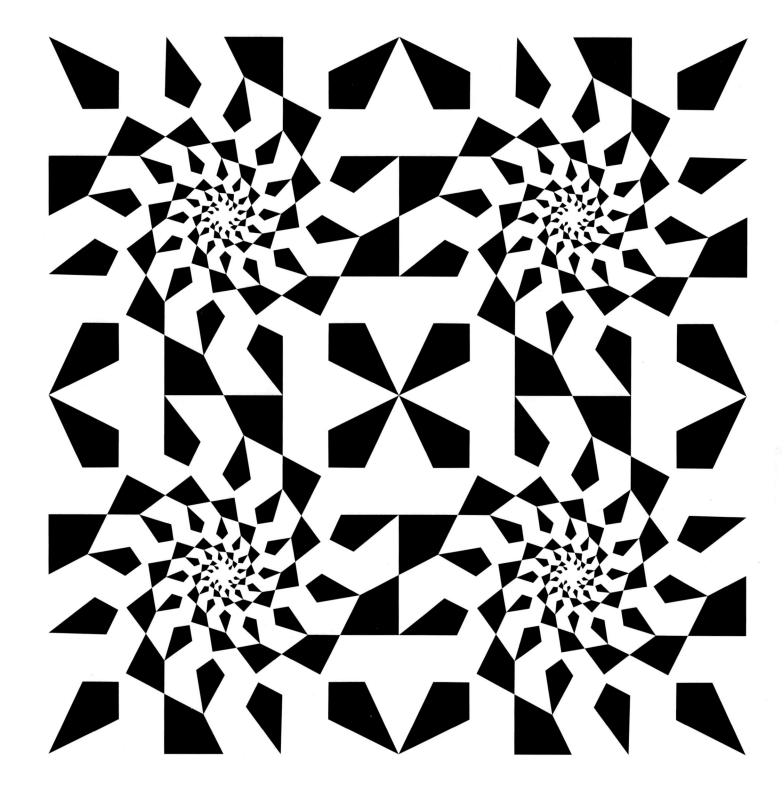

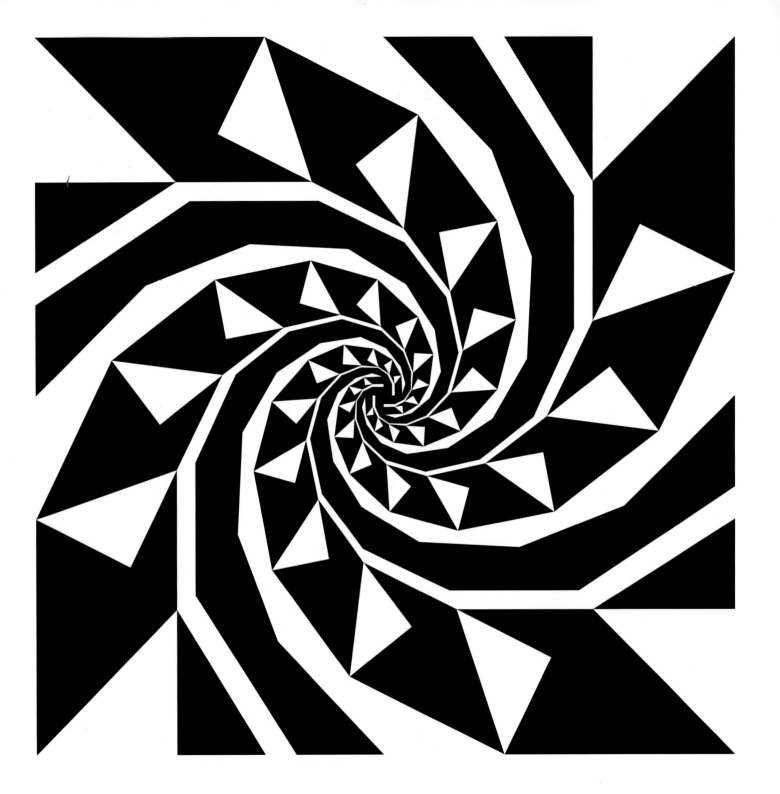

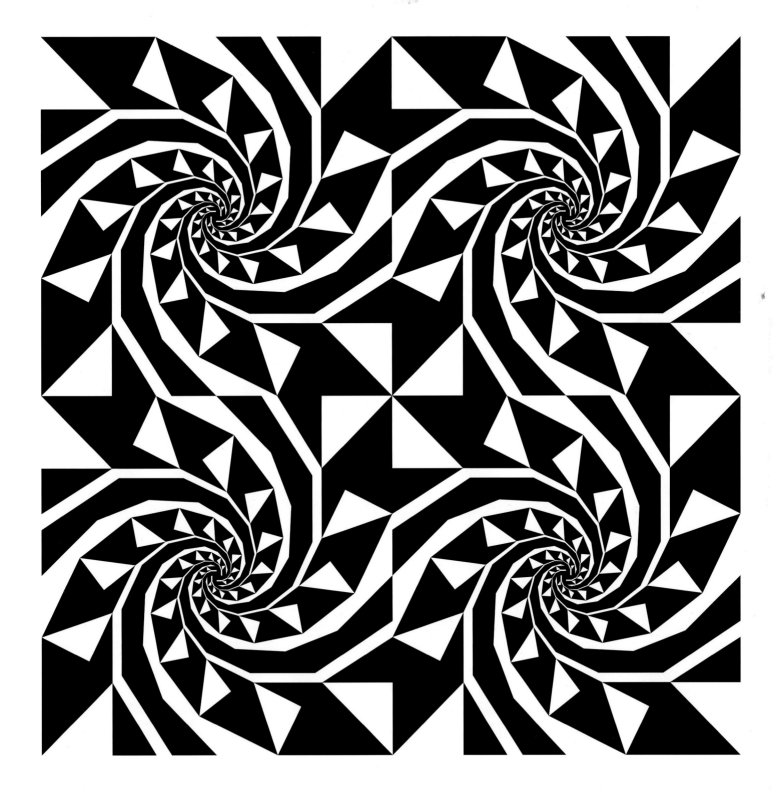

71

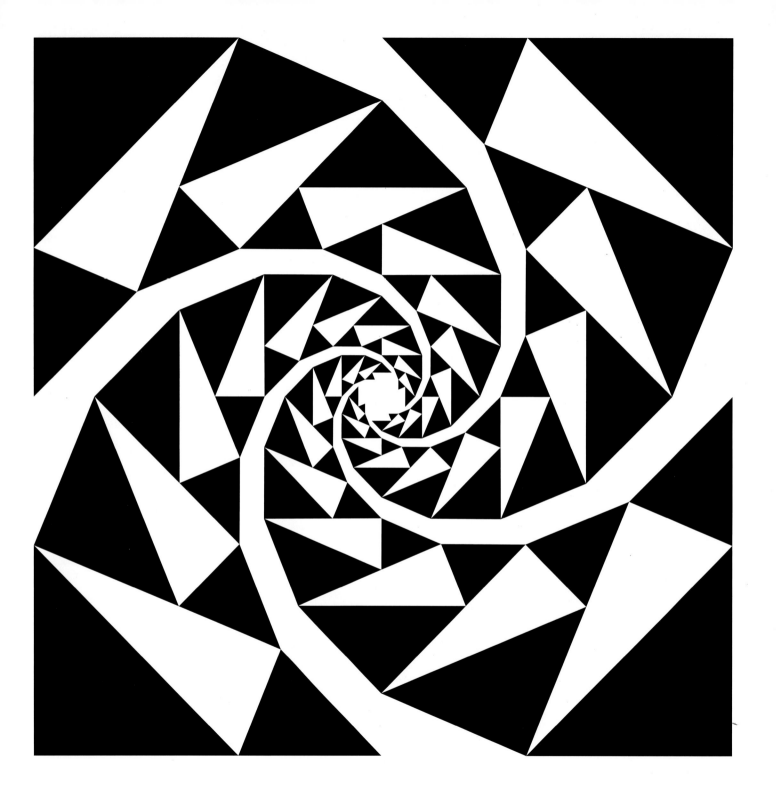

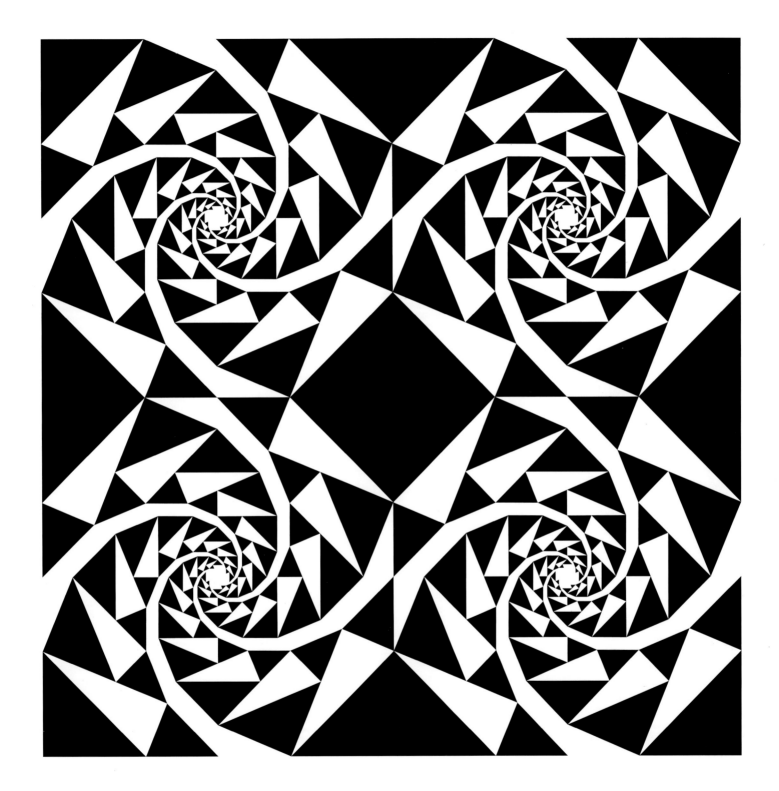

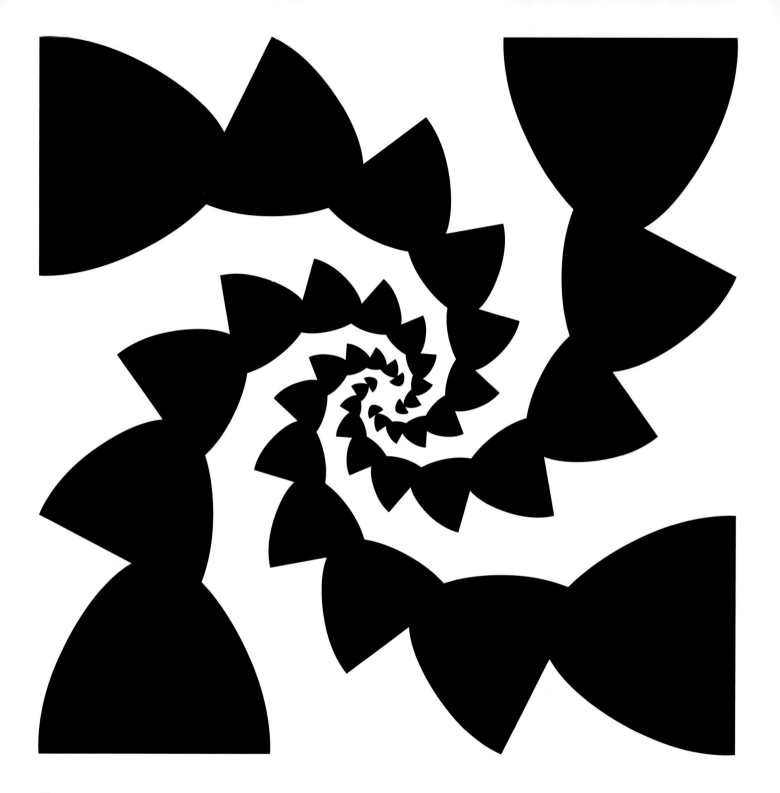

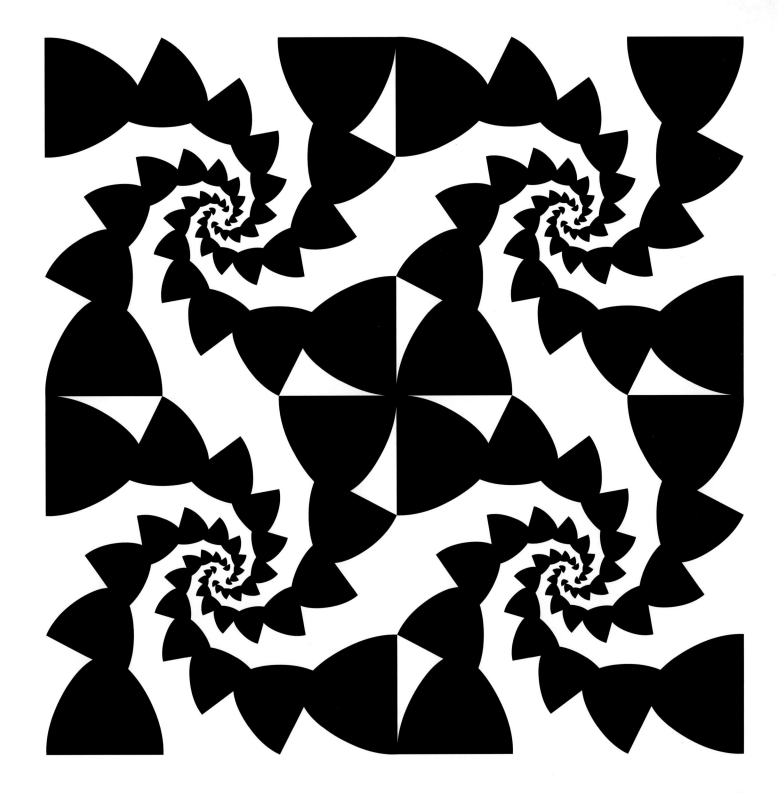

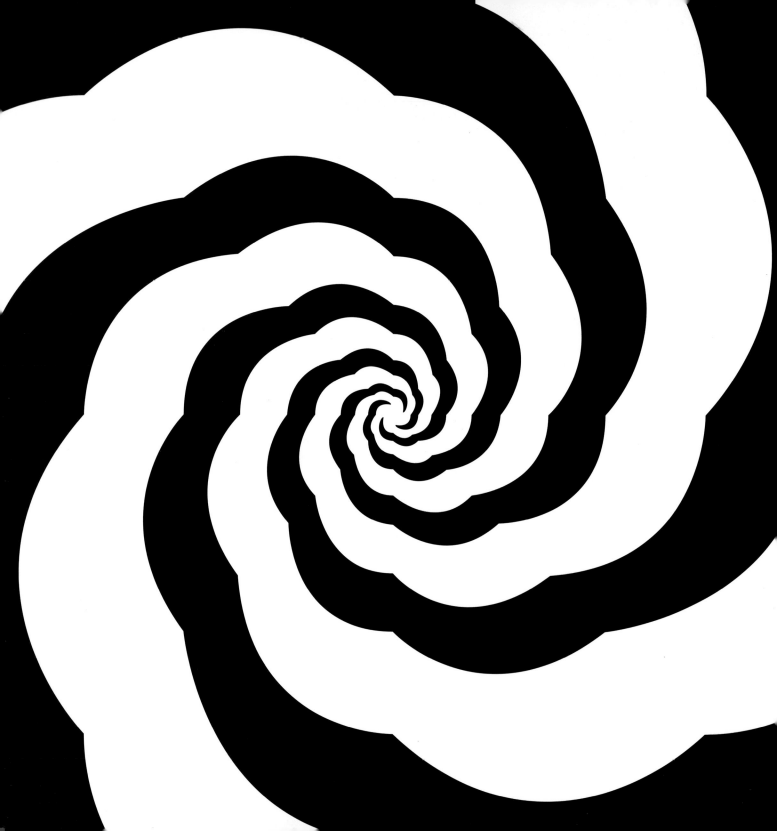

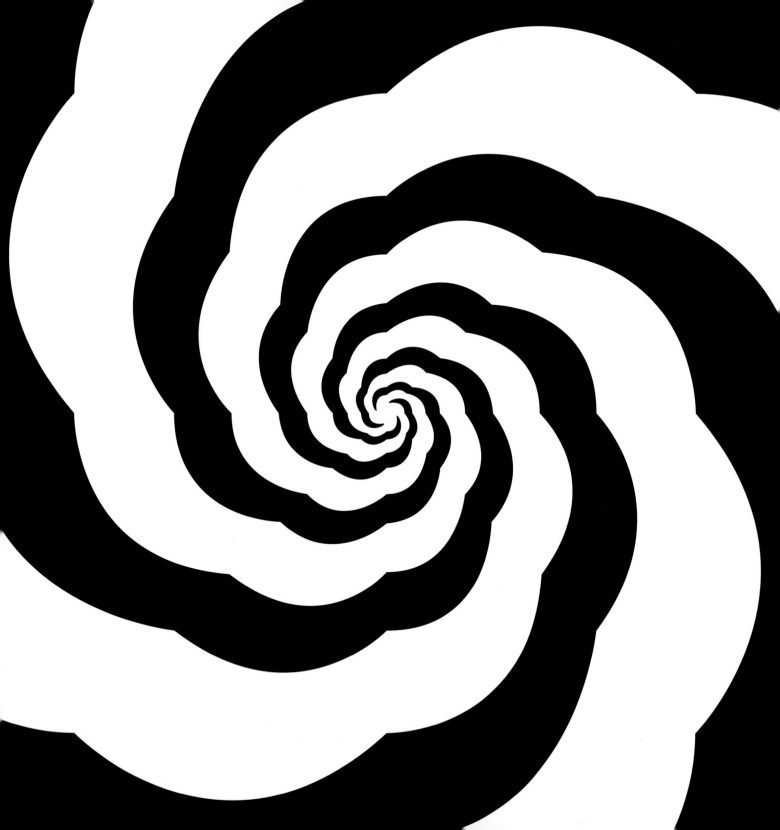

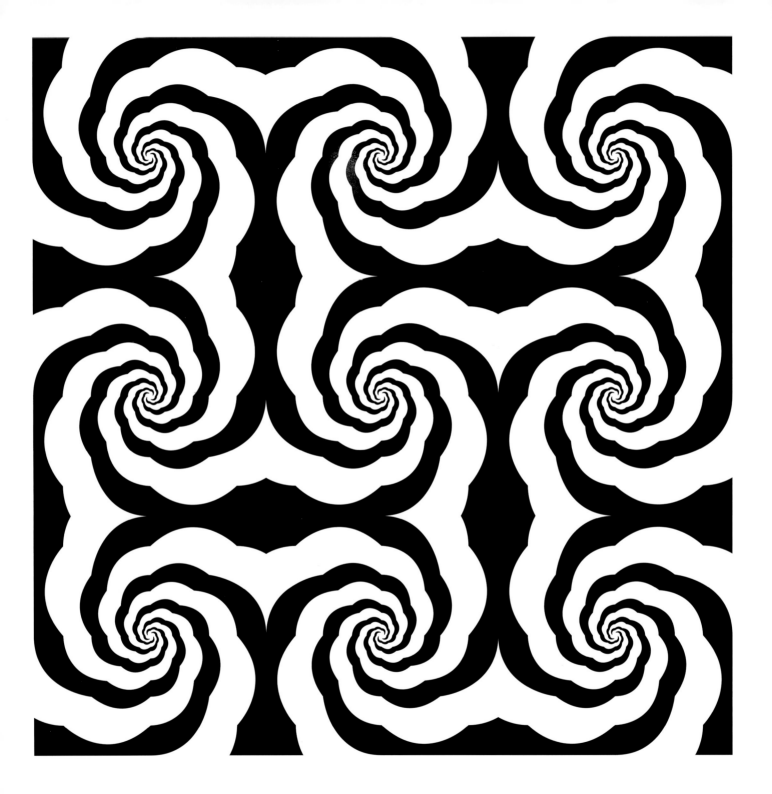

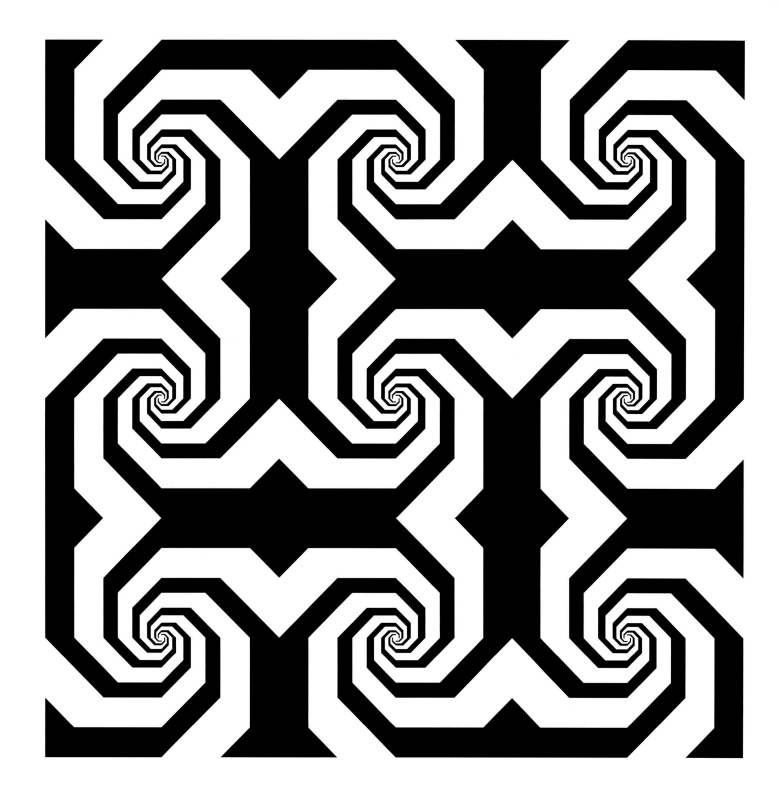

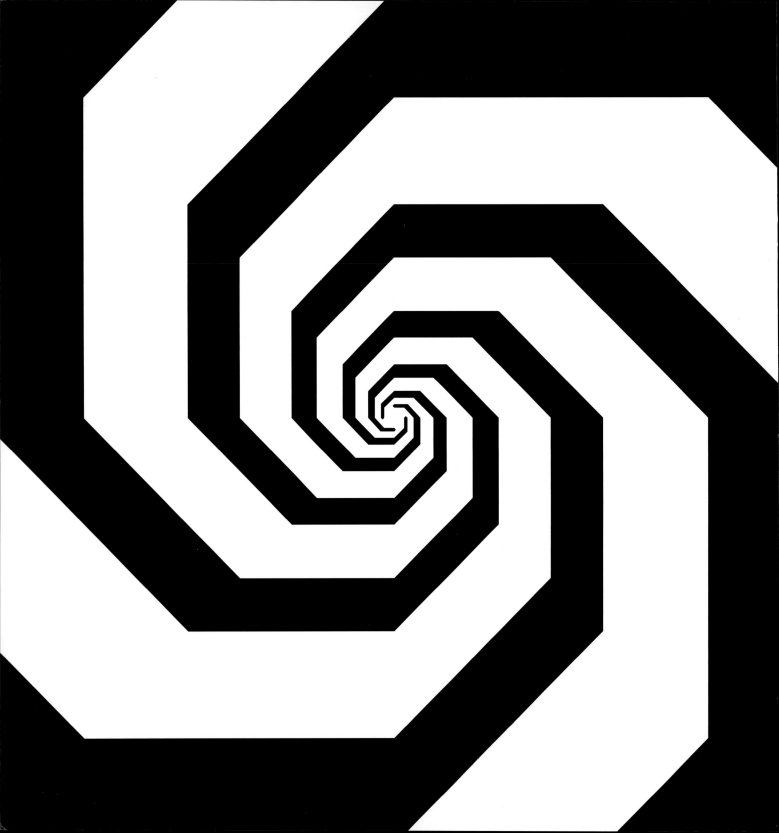

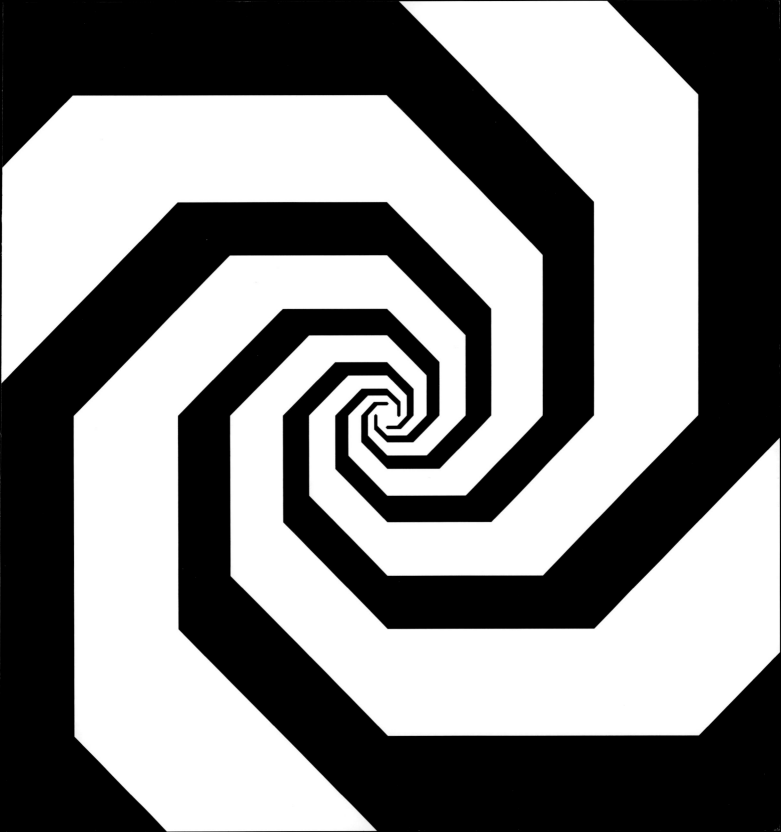

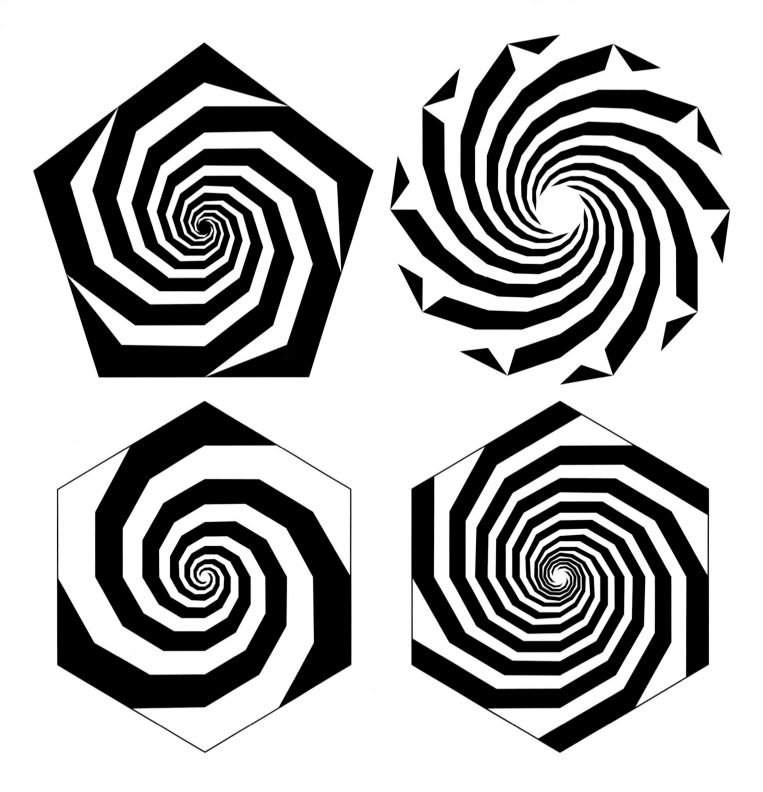

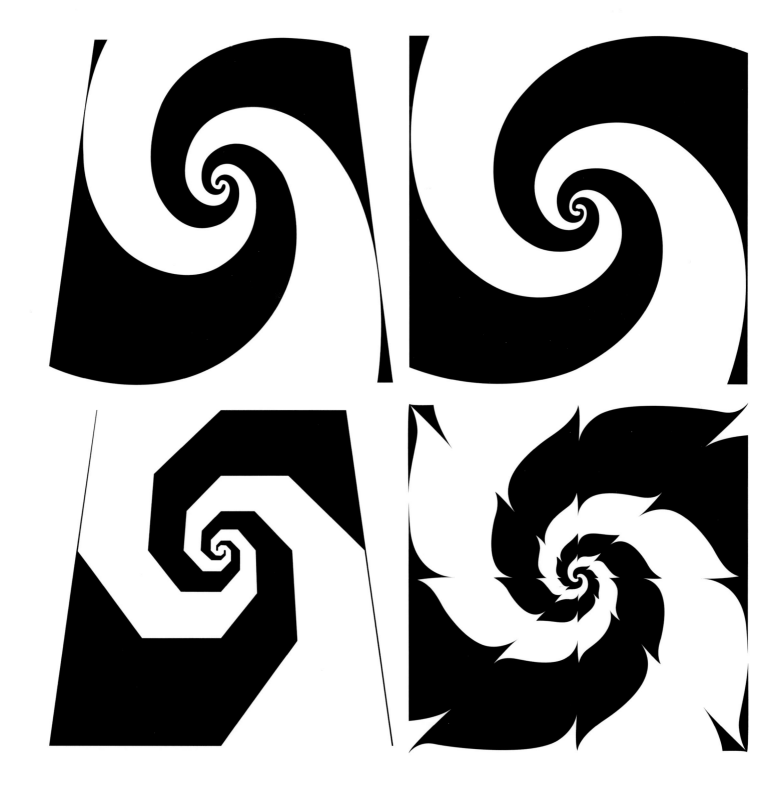

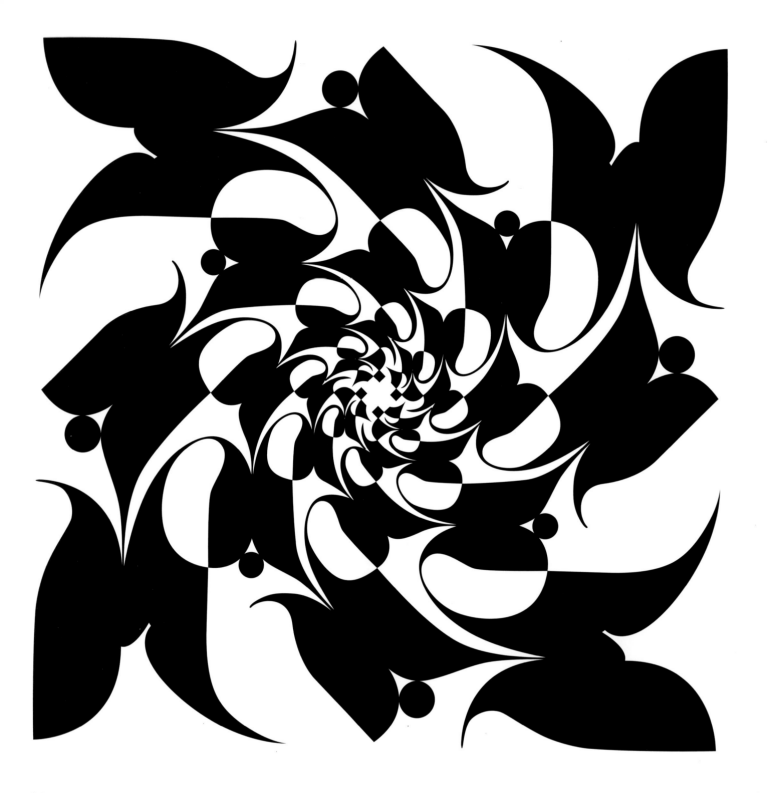

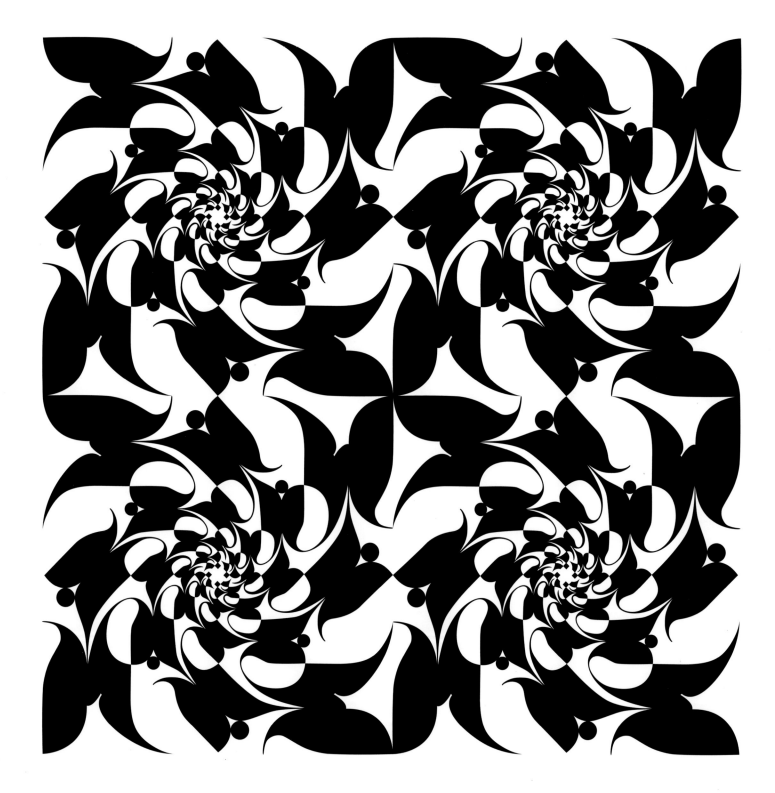

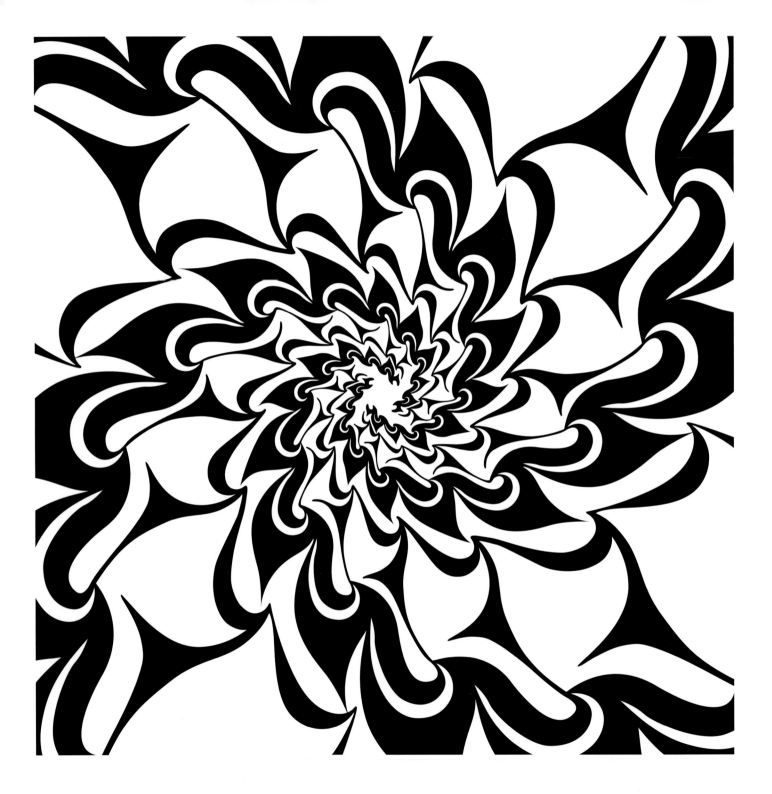

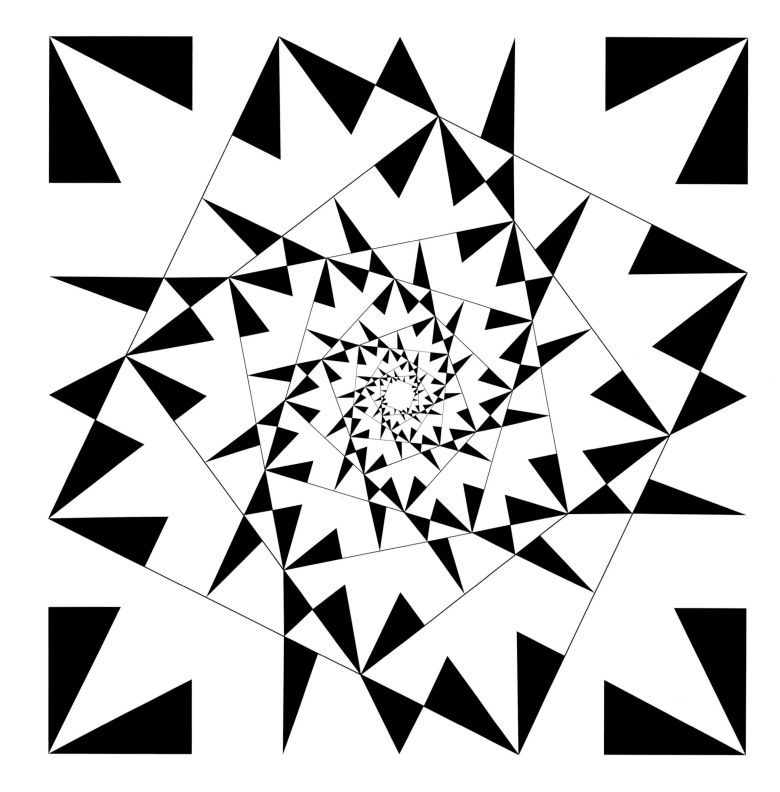

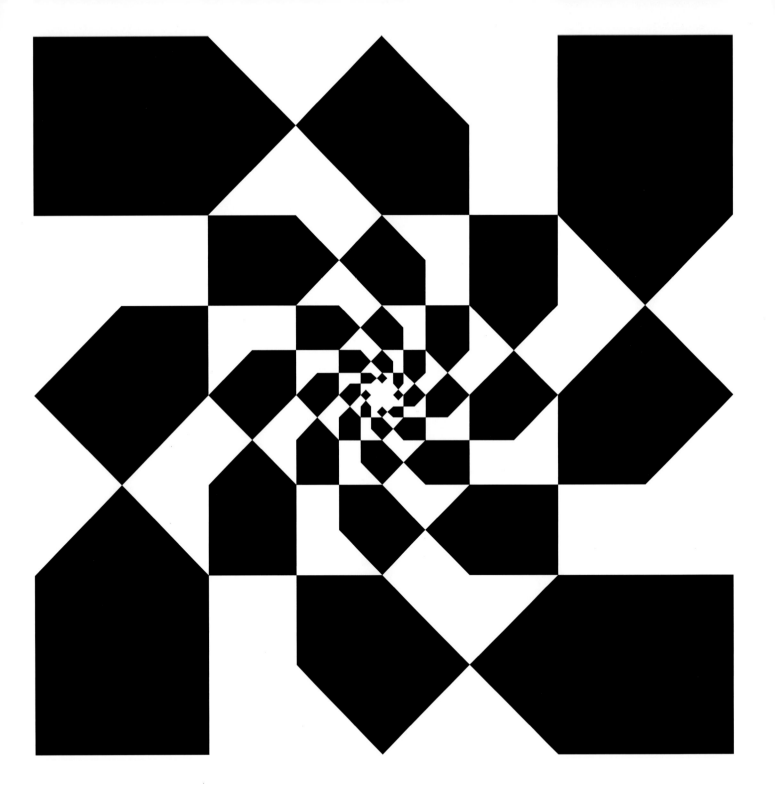

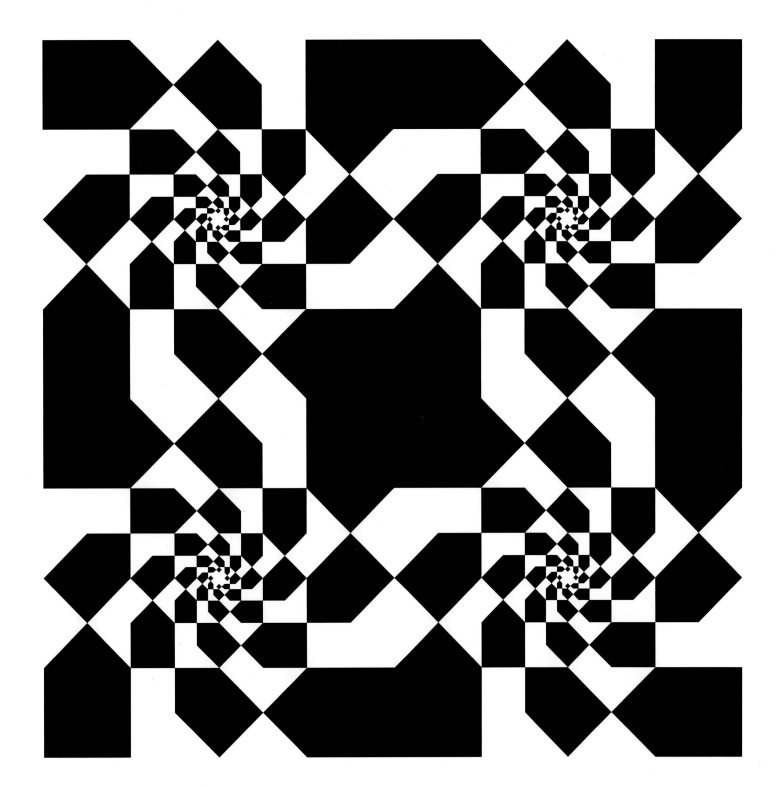

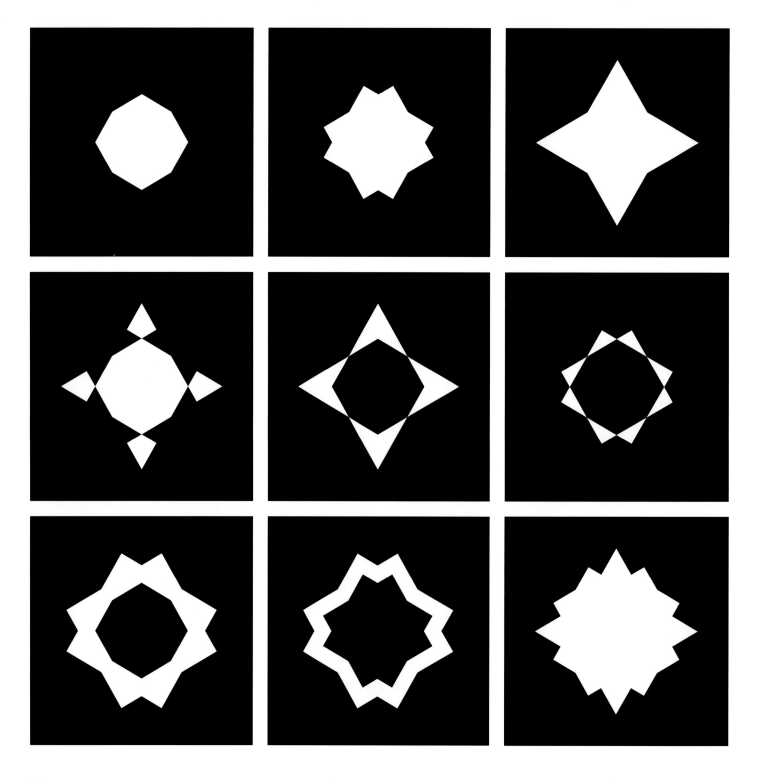

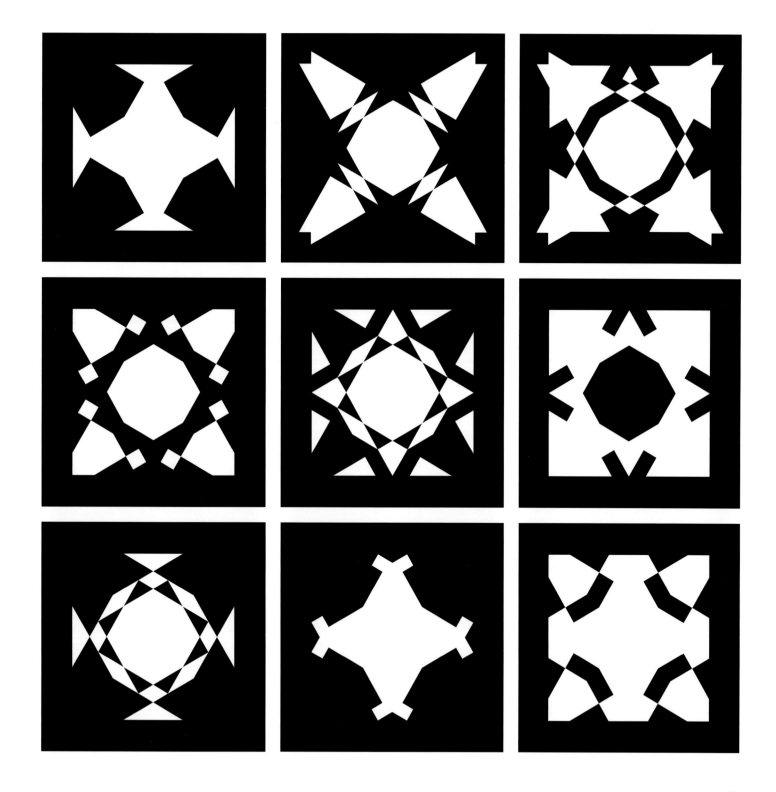

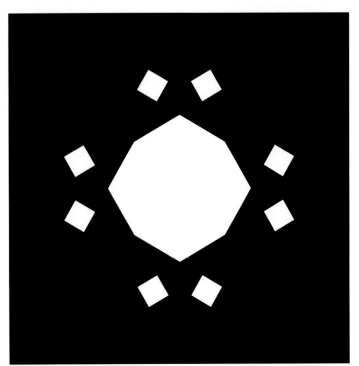

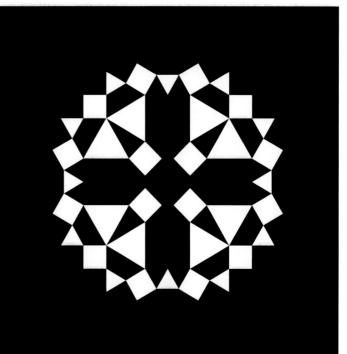
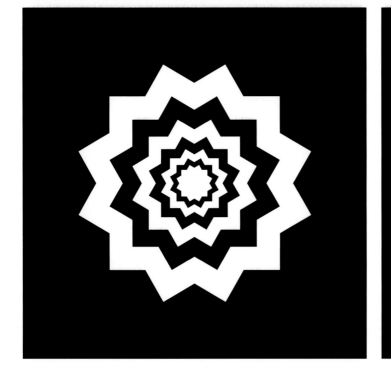
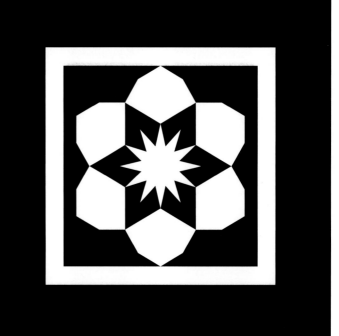

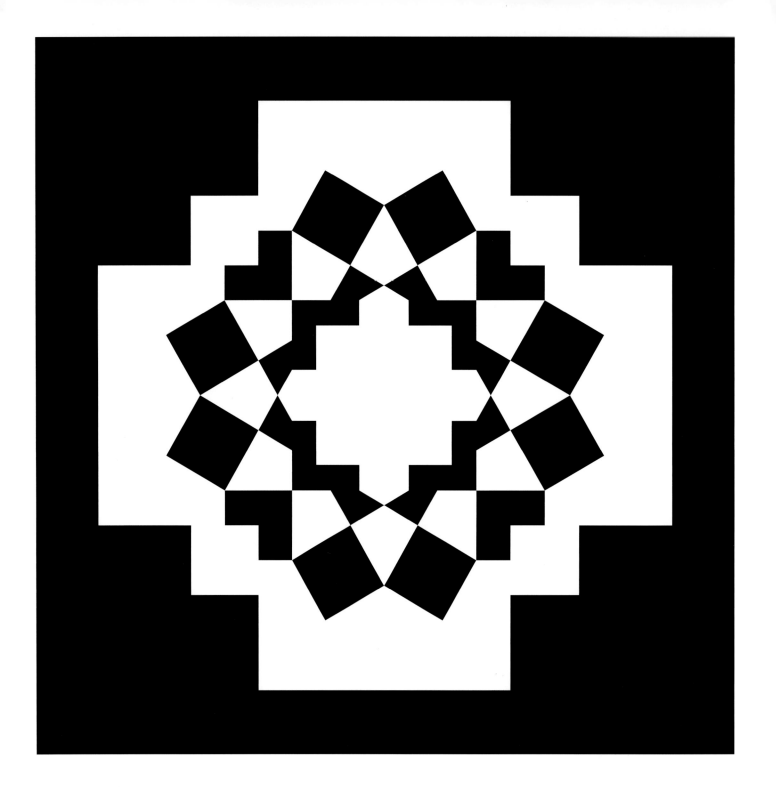

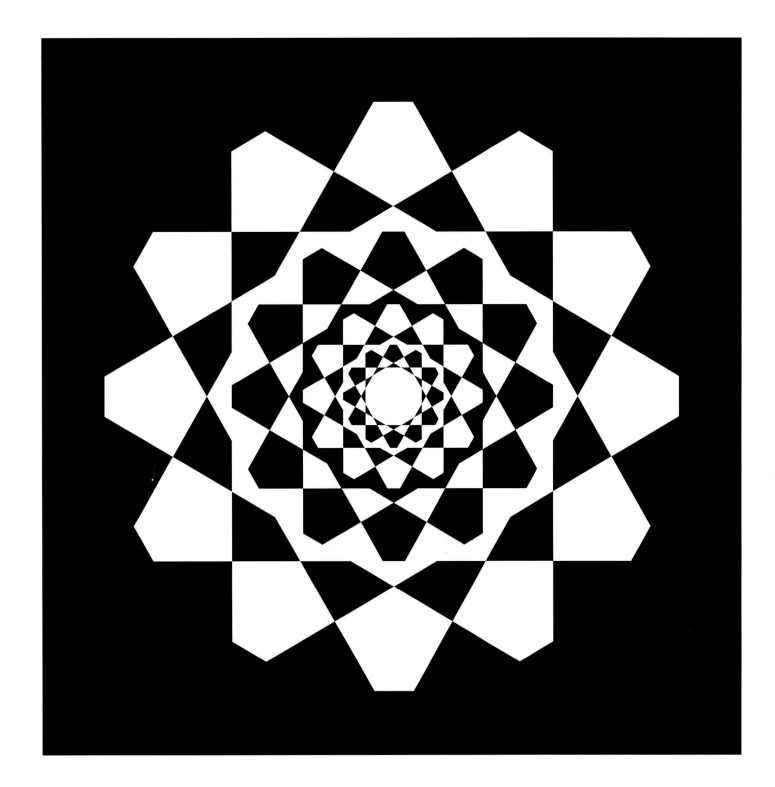

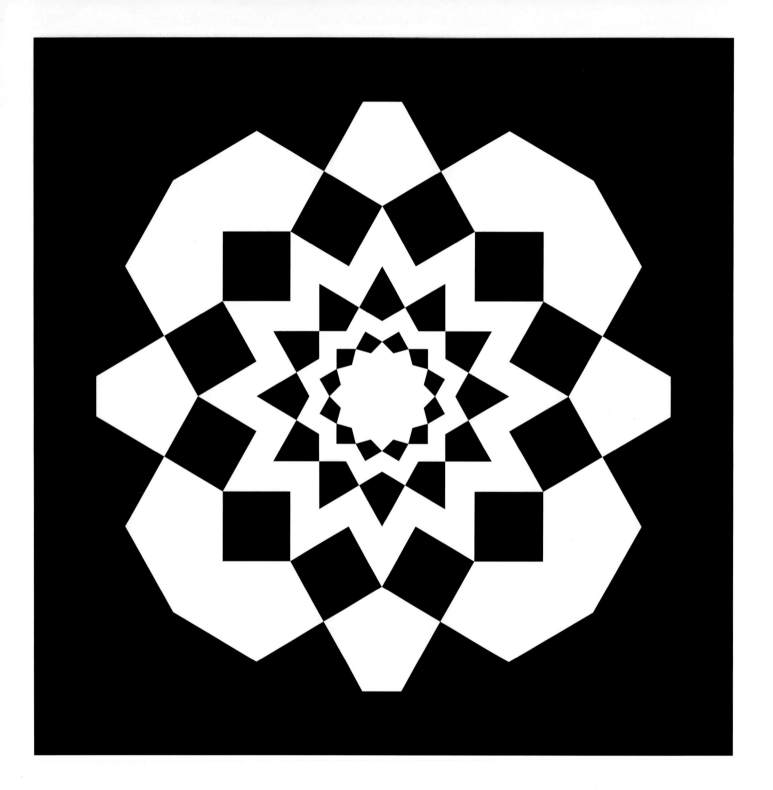

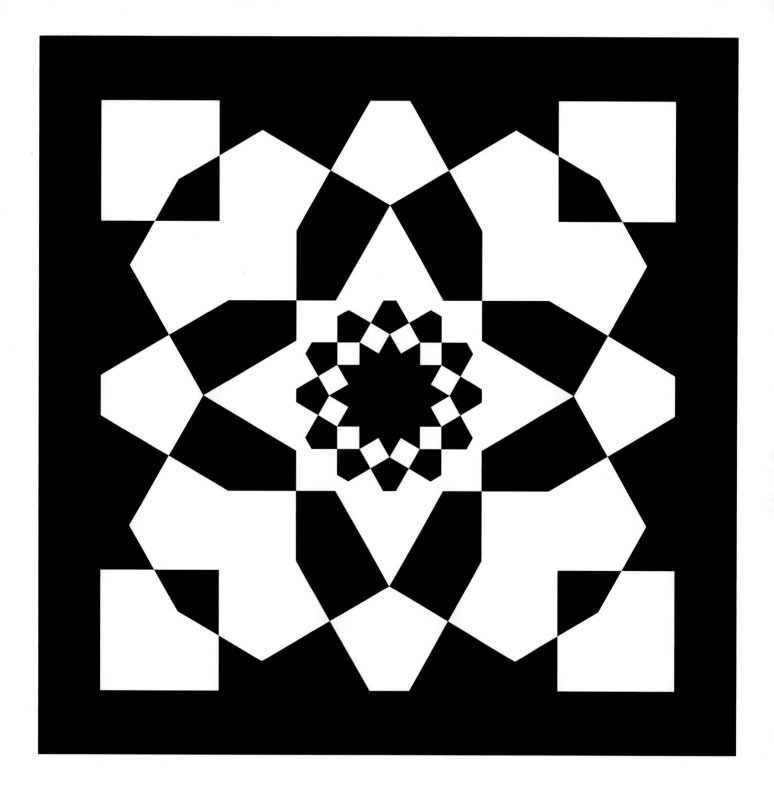

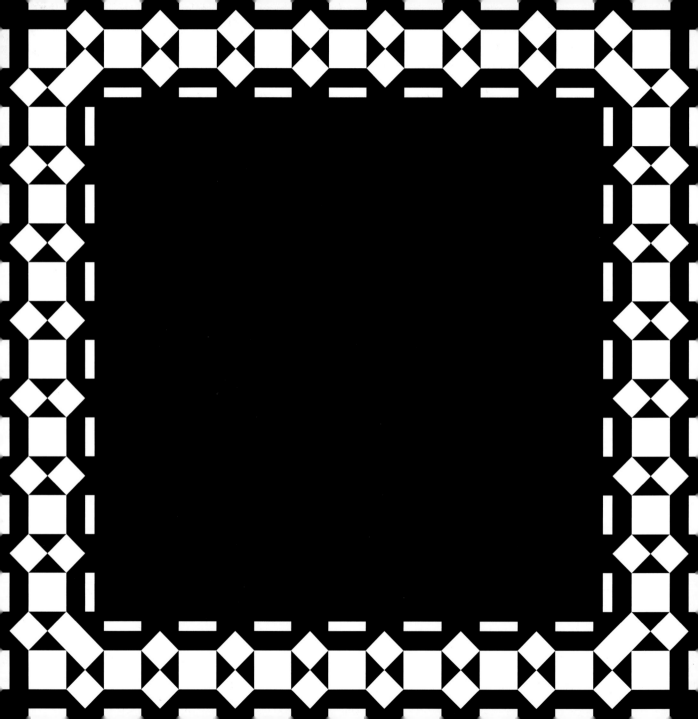

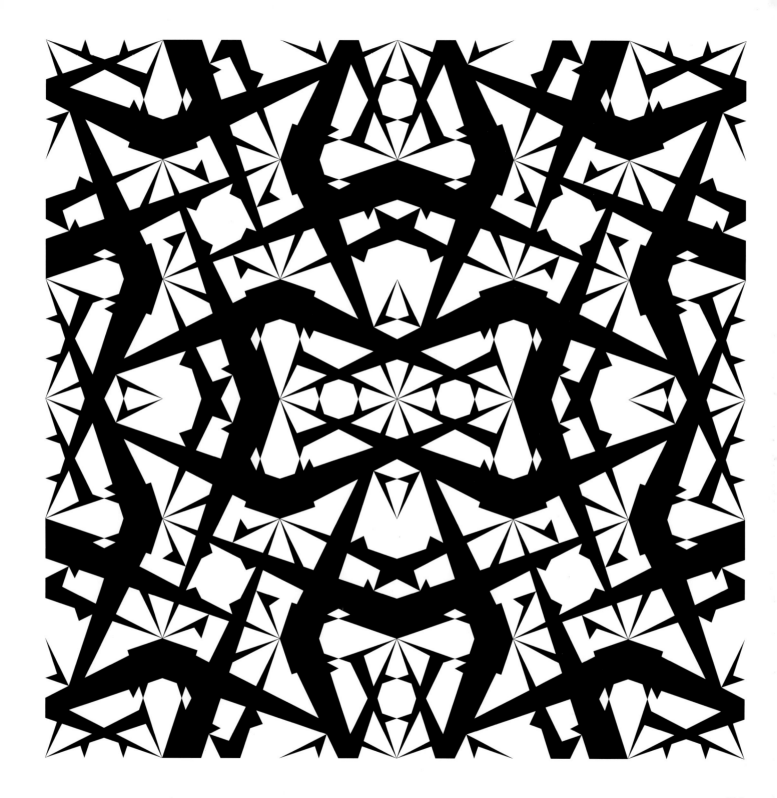

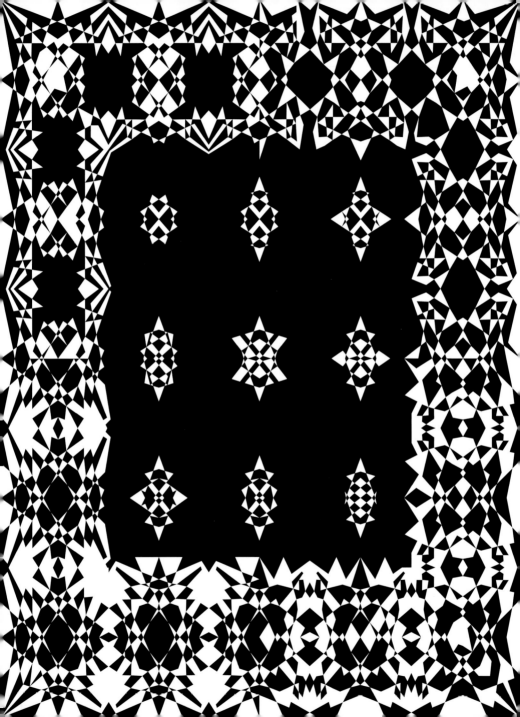

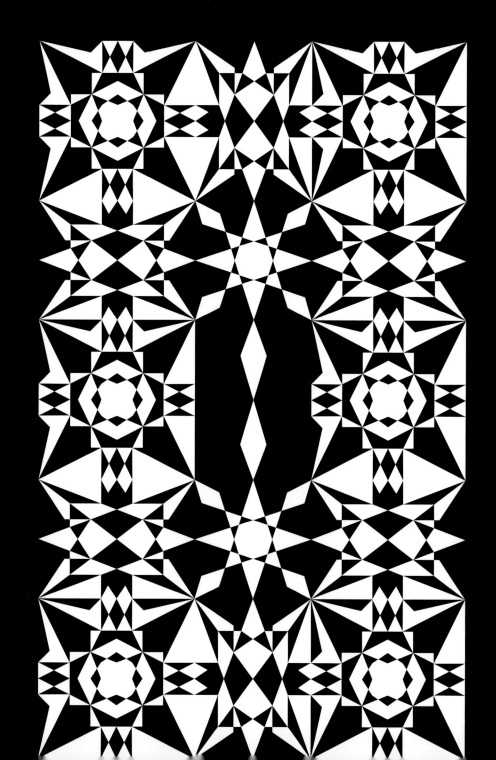

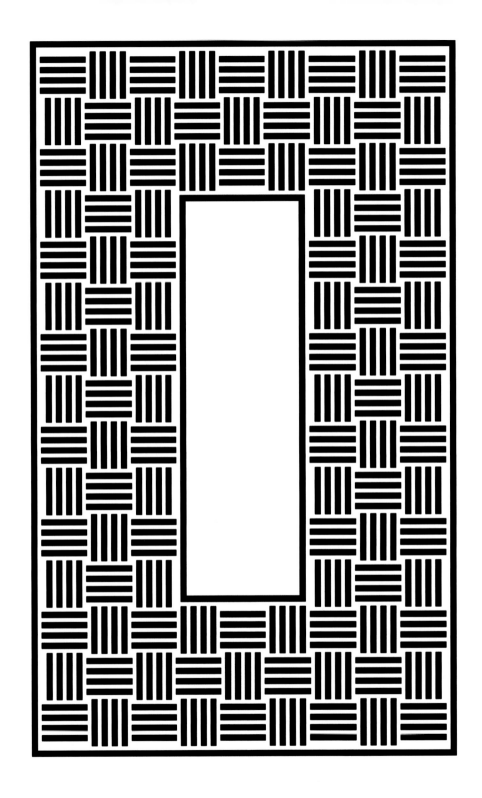

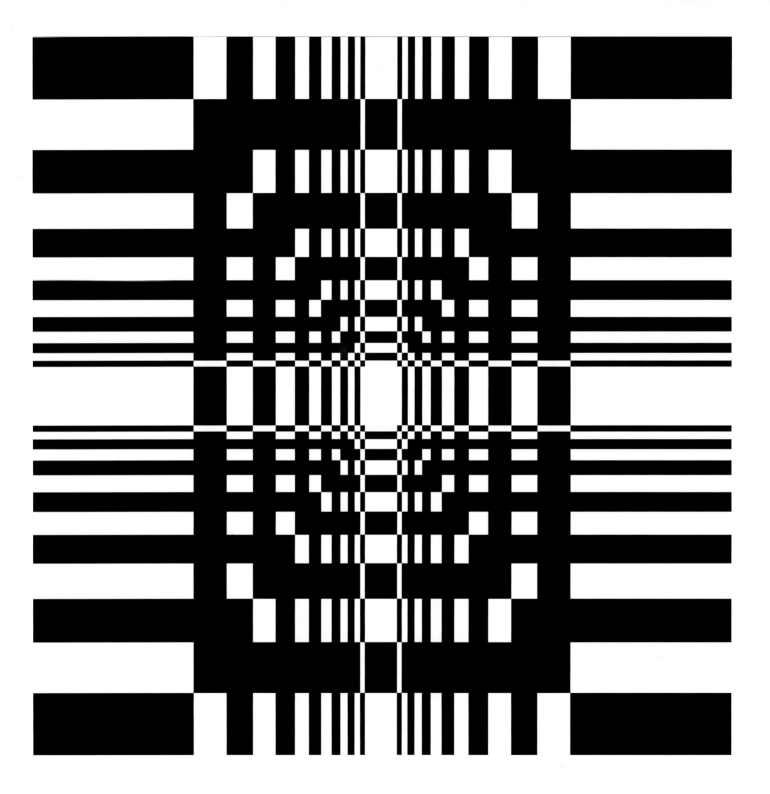

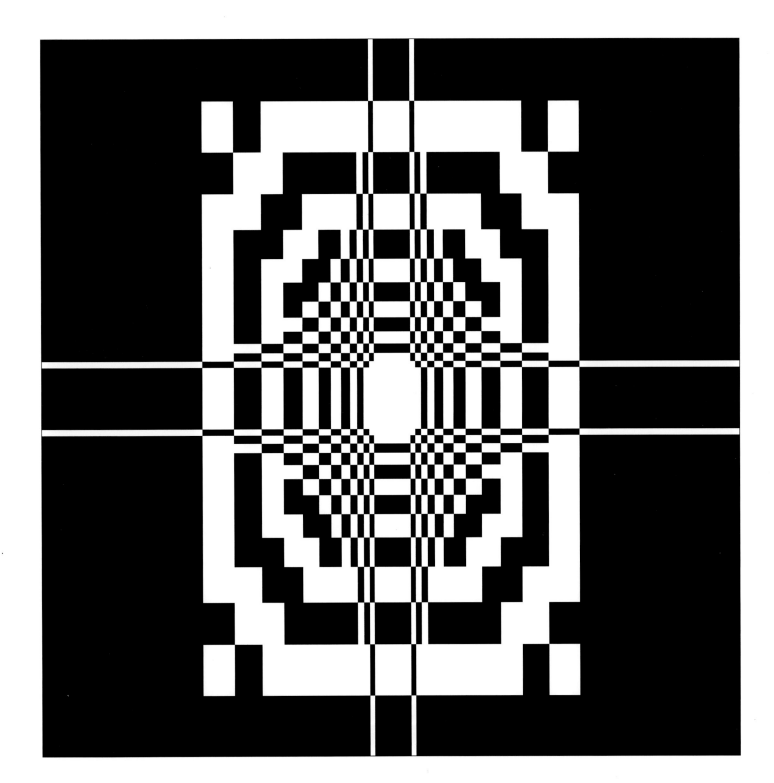

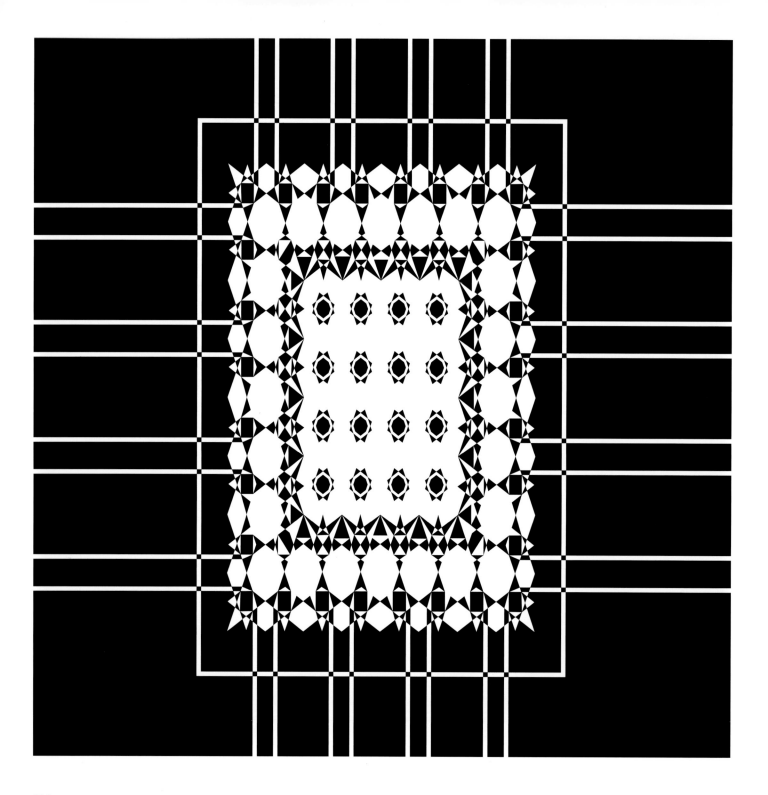

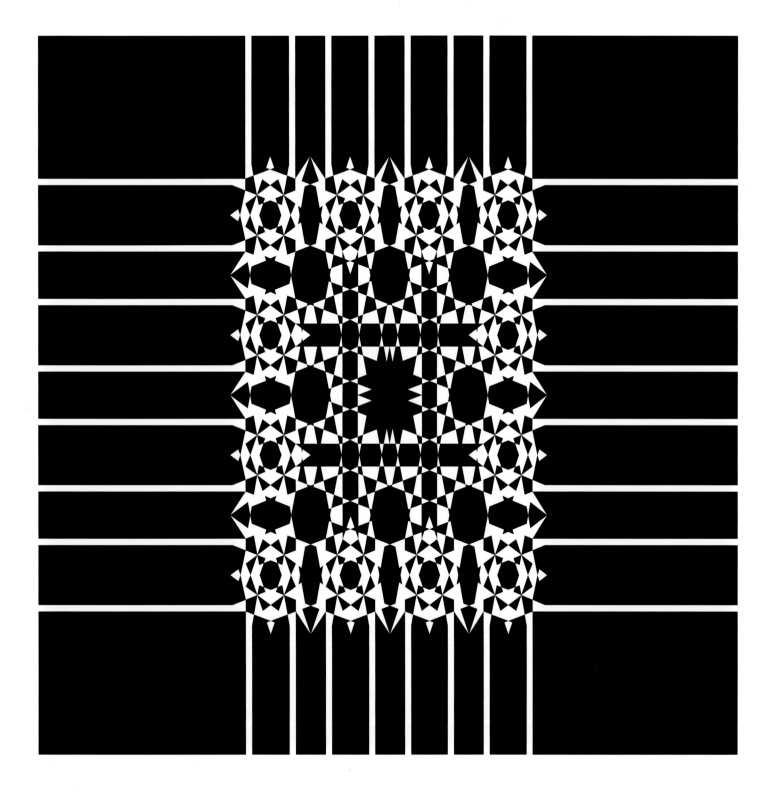

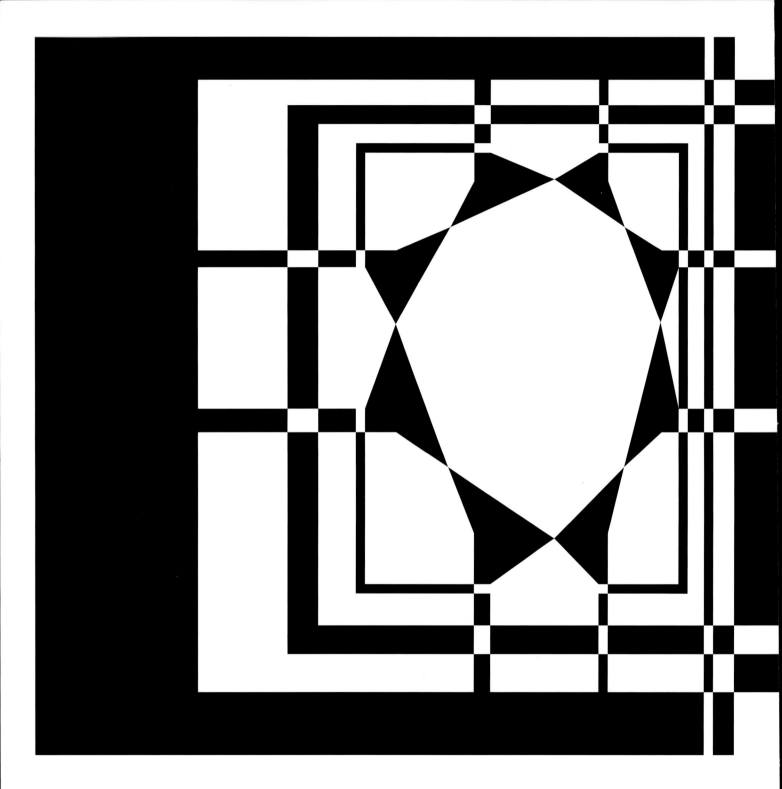

114

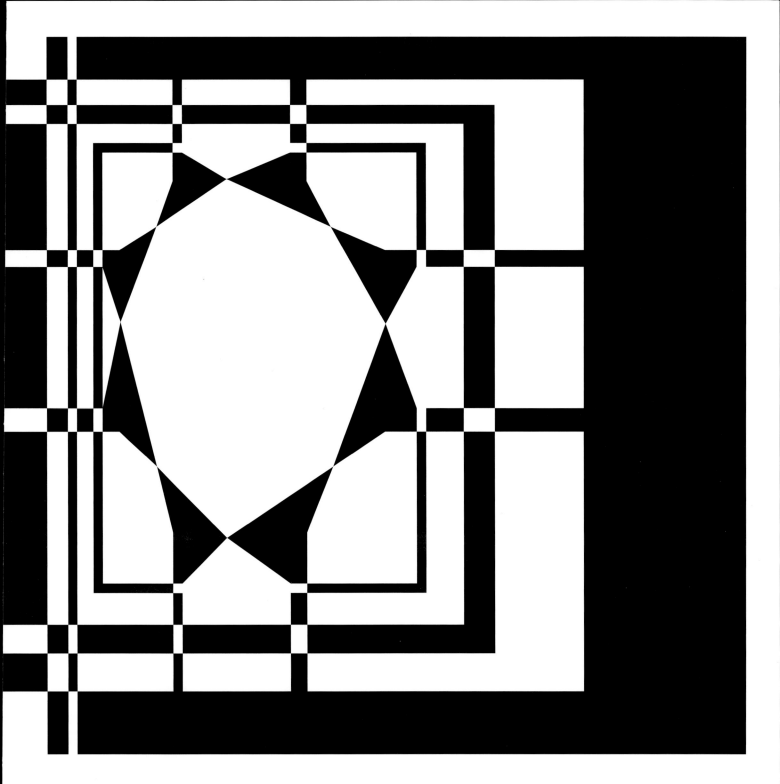

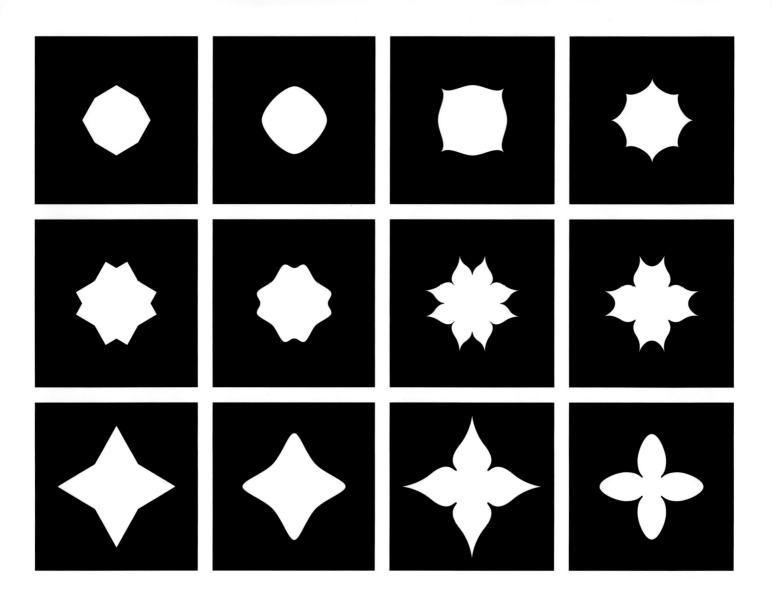

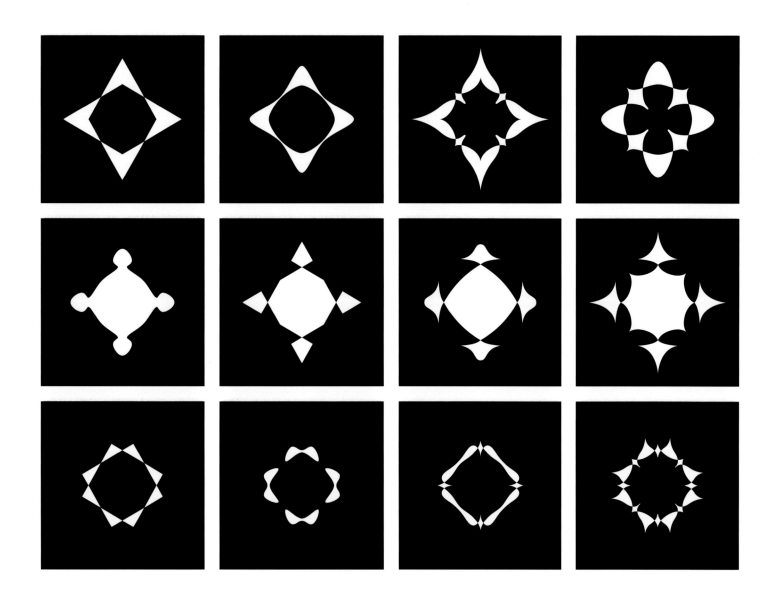

 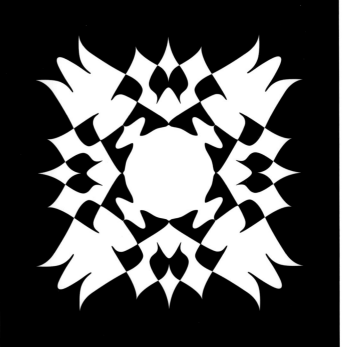

119

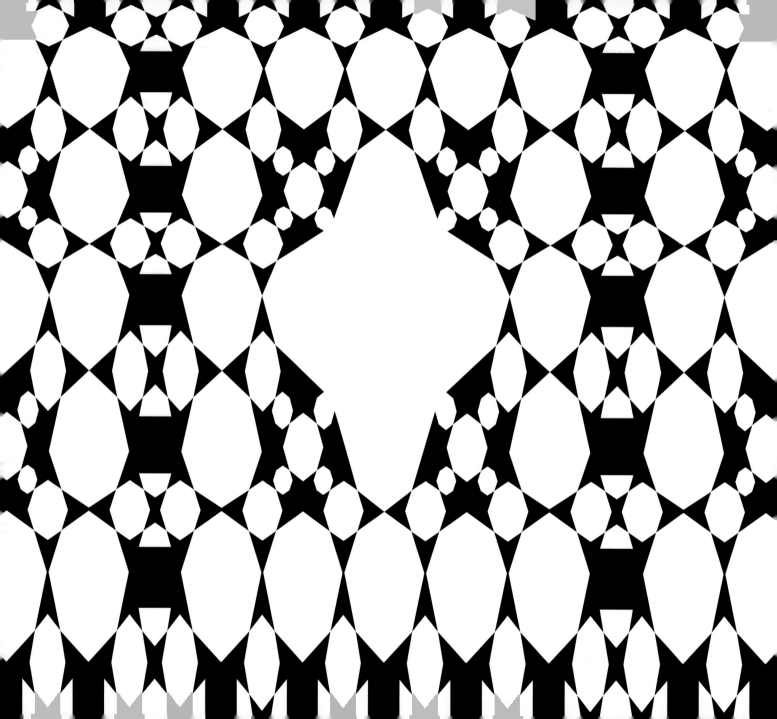

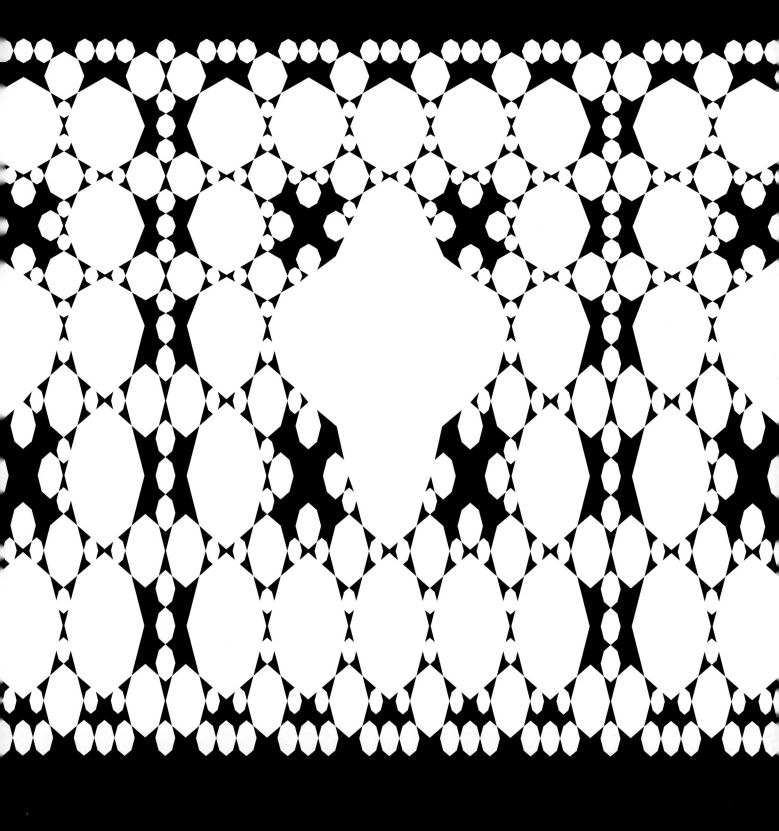

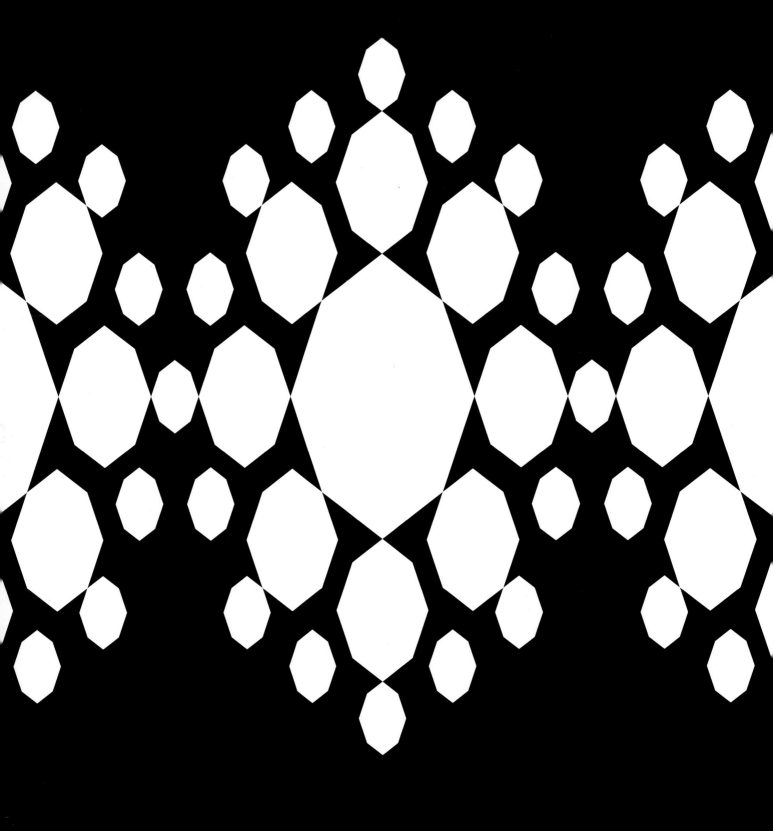

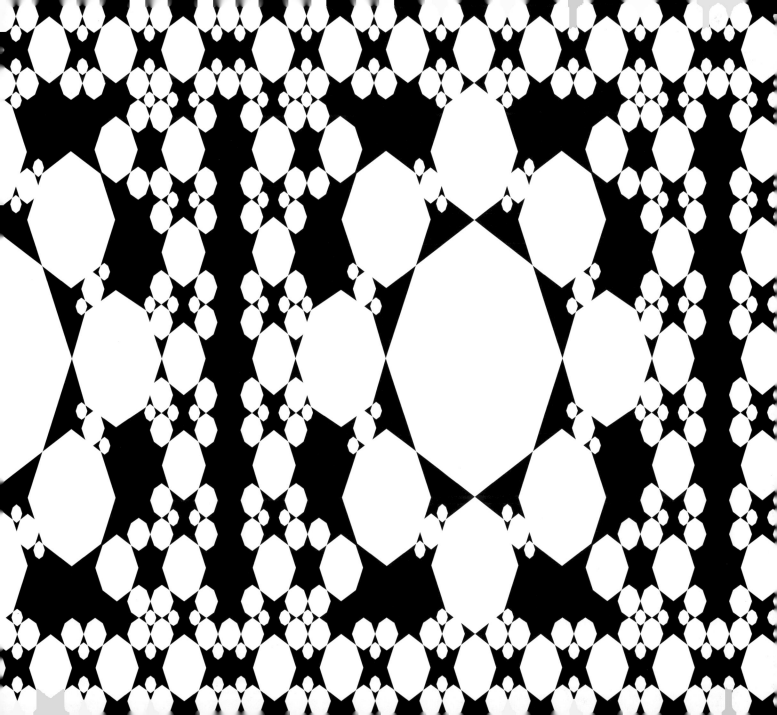

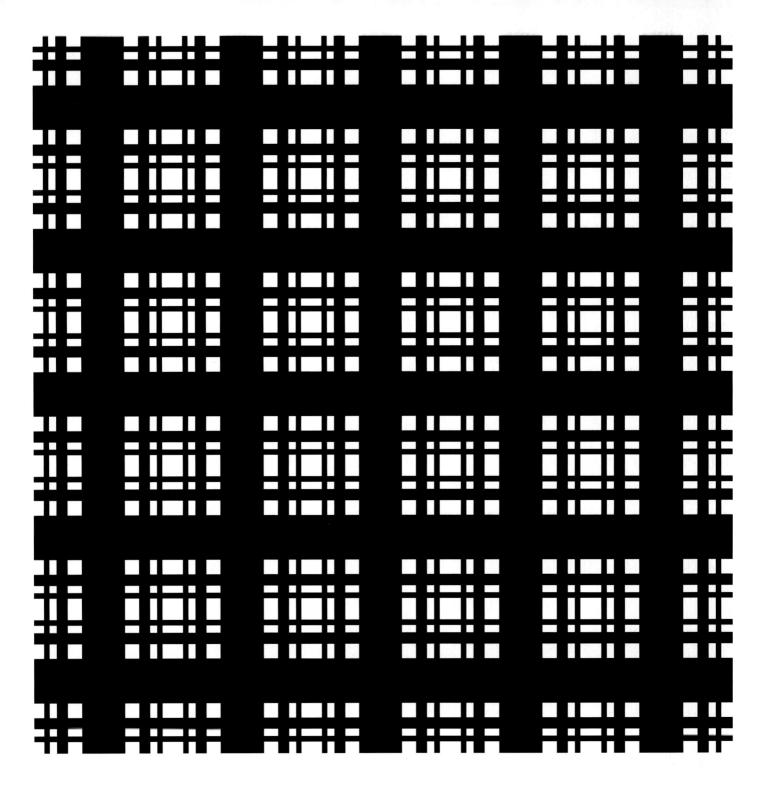

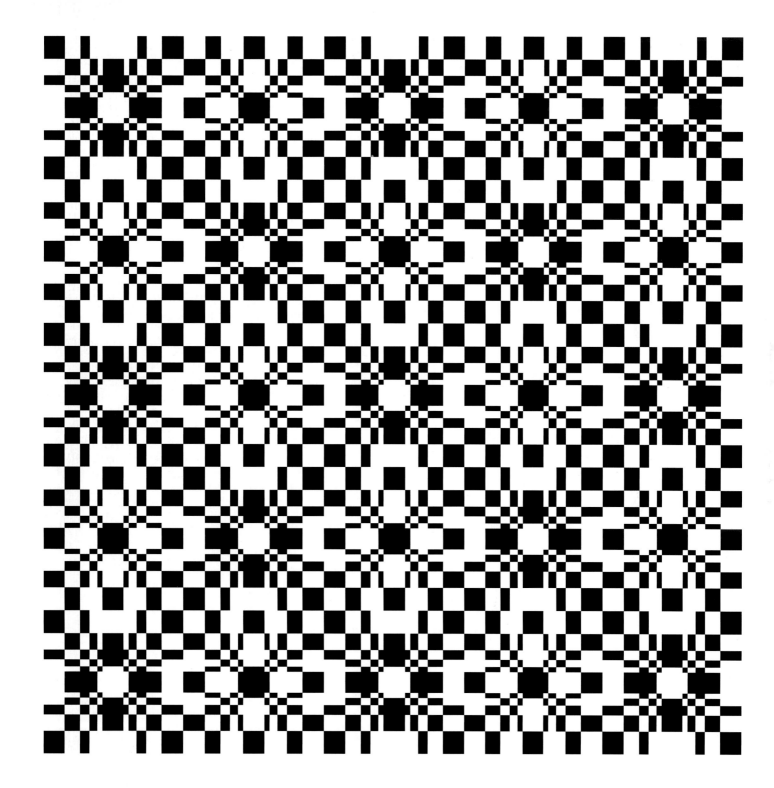

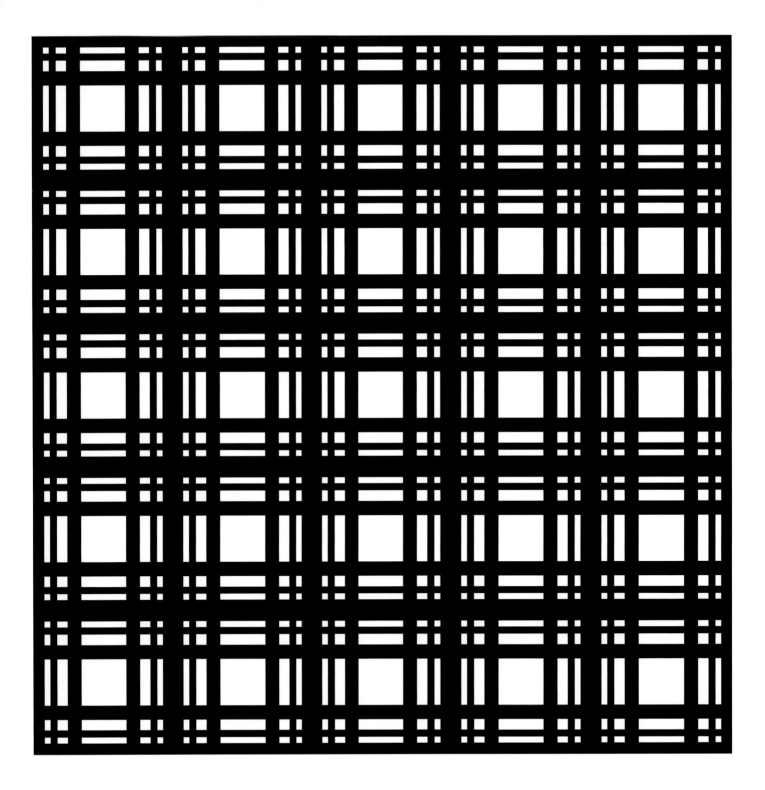

126

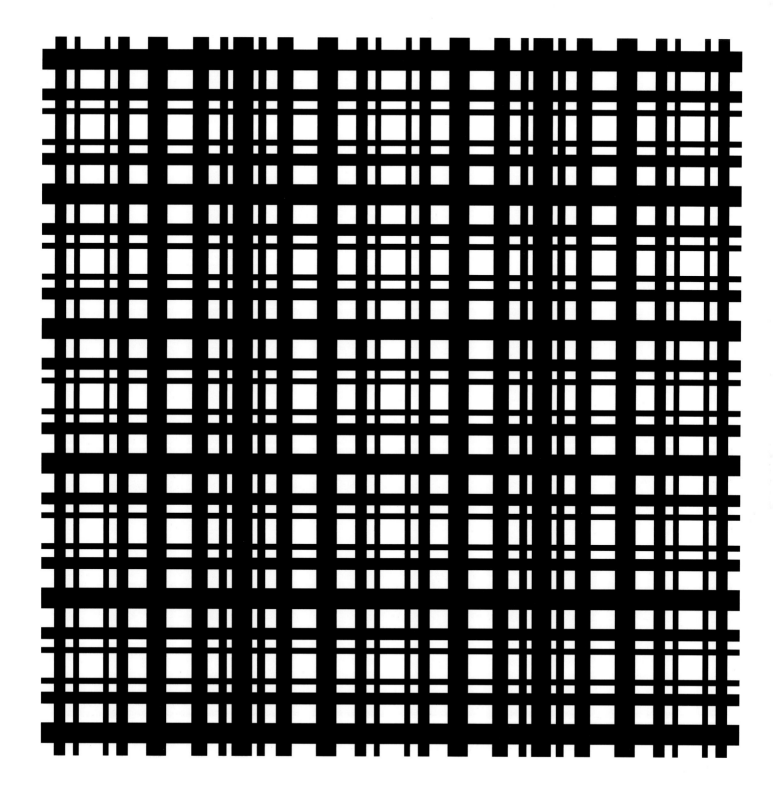

127

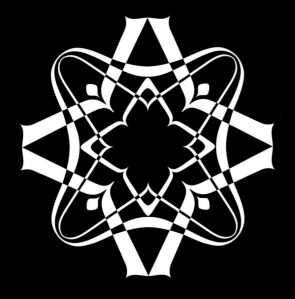
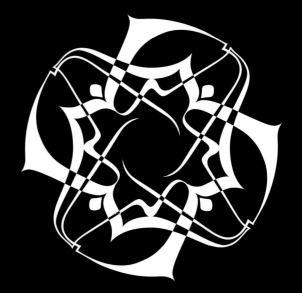
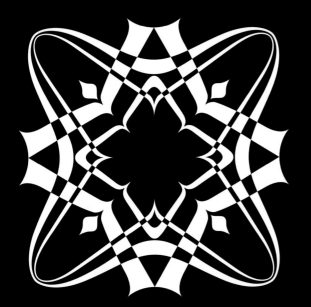
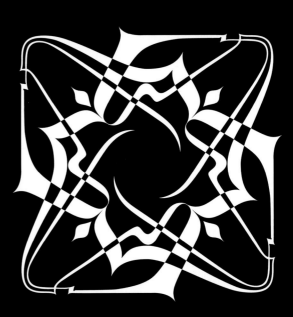

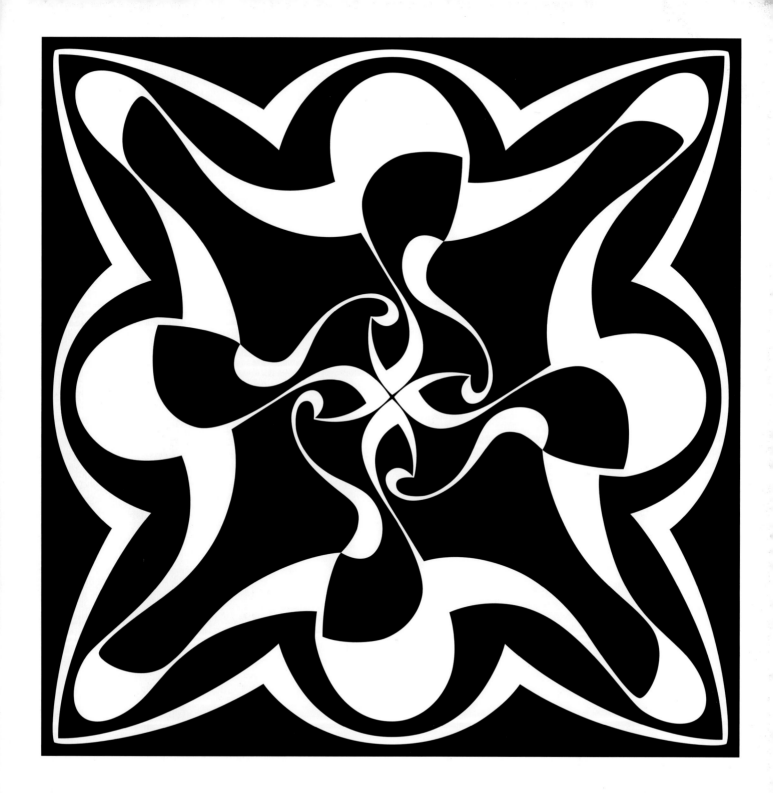

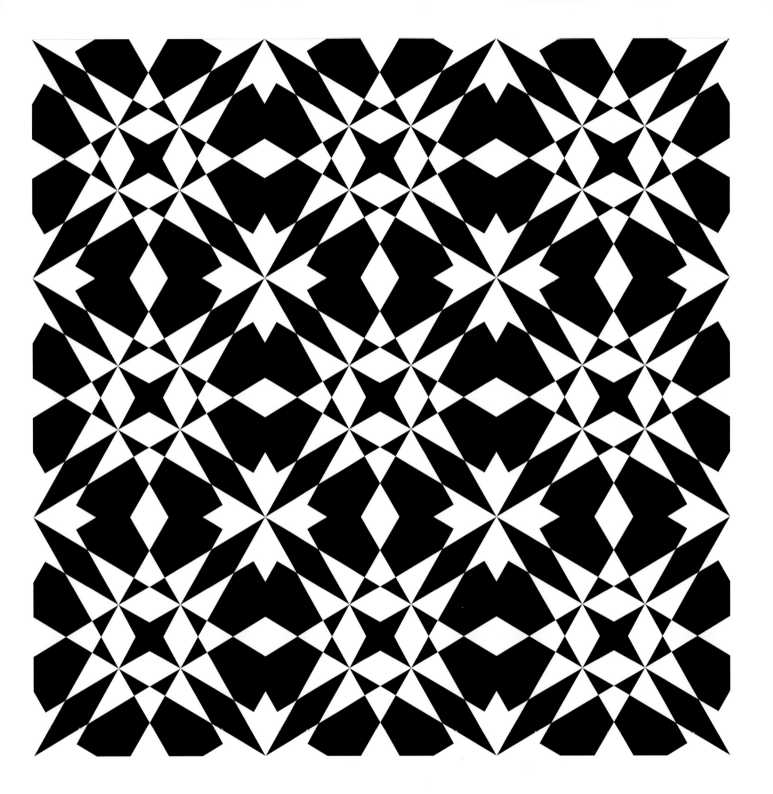

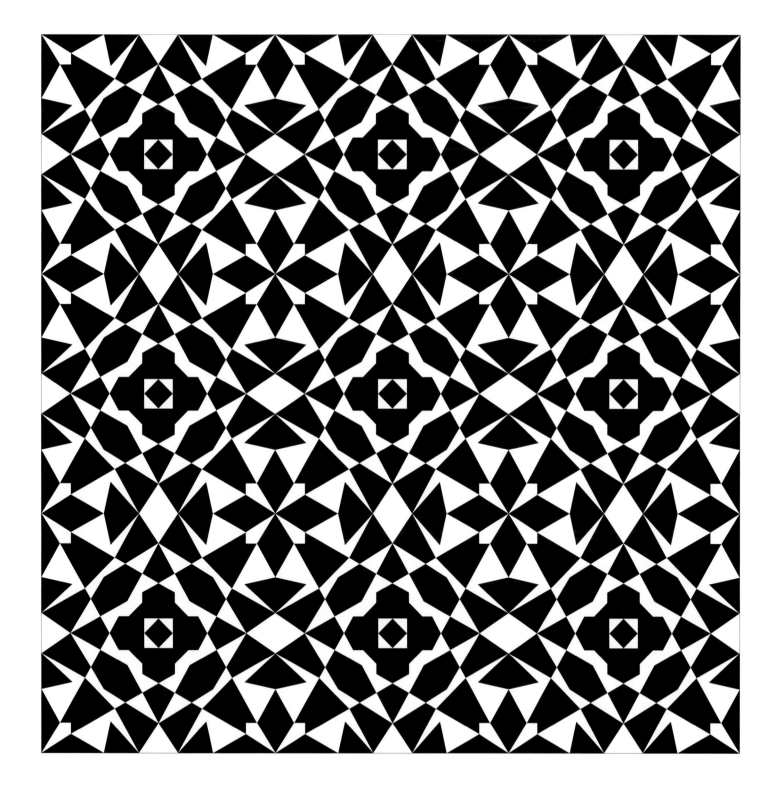

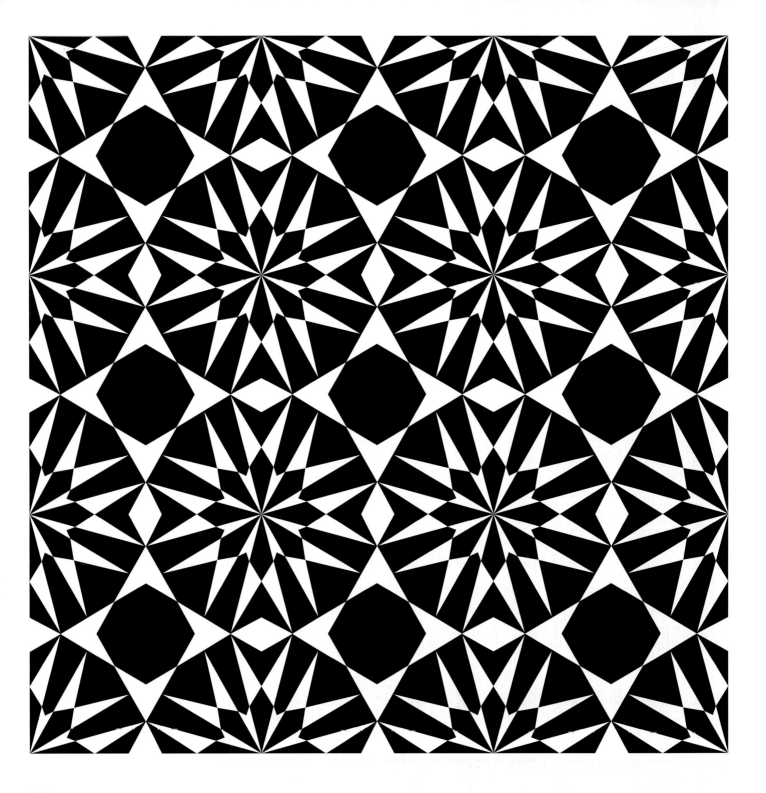

132

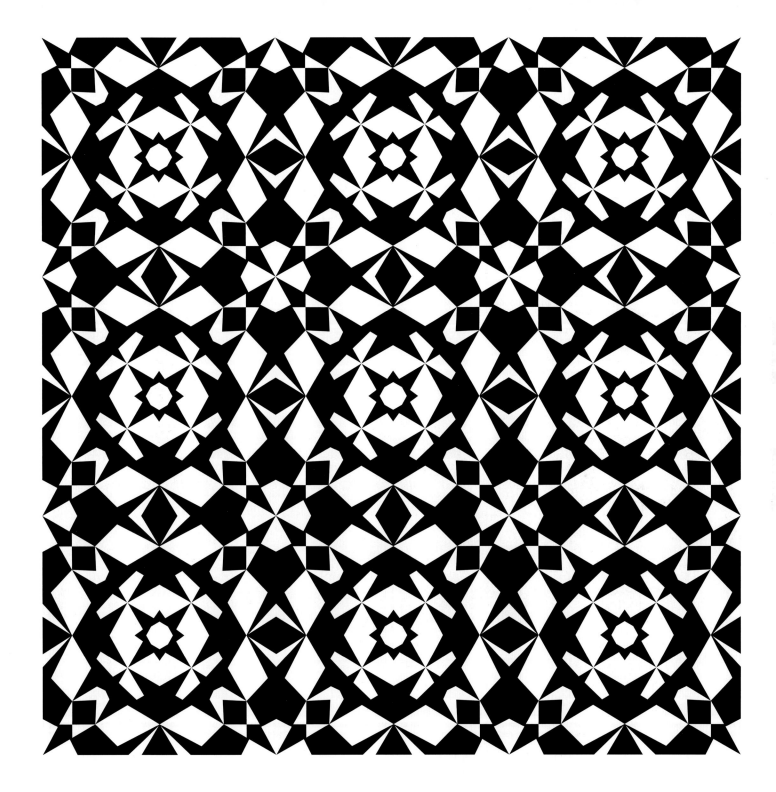

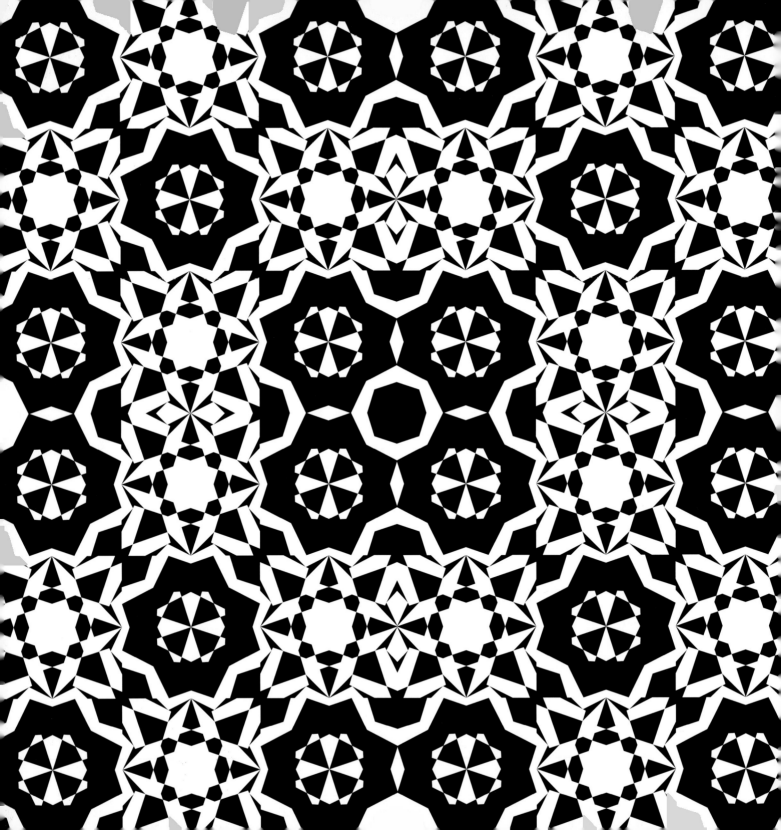

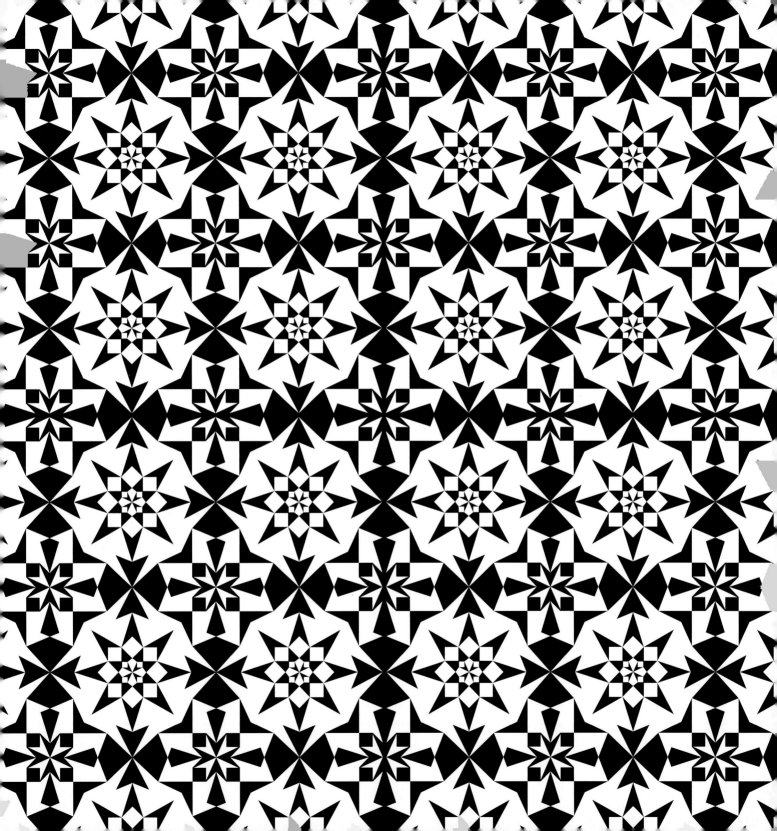

138

139

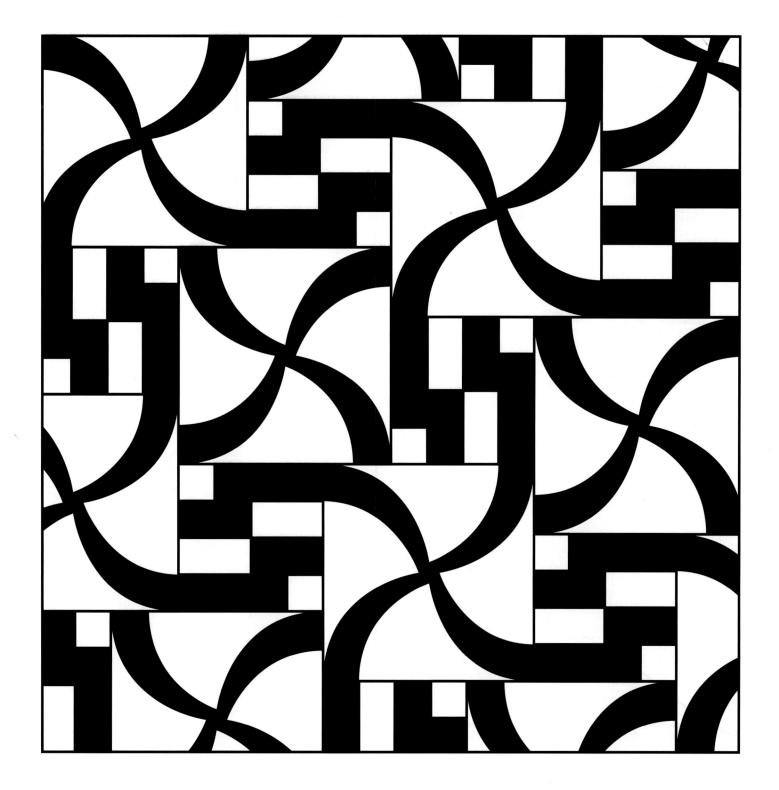

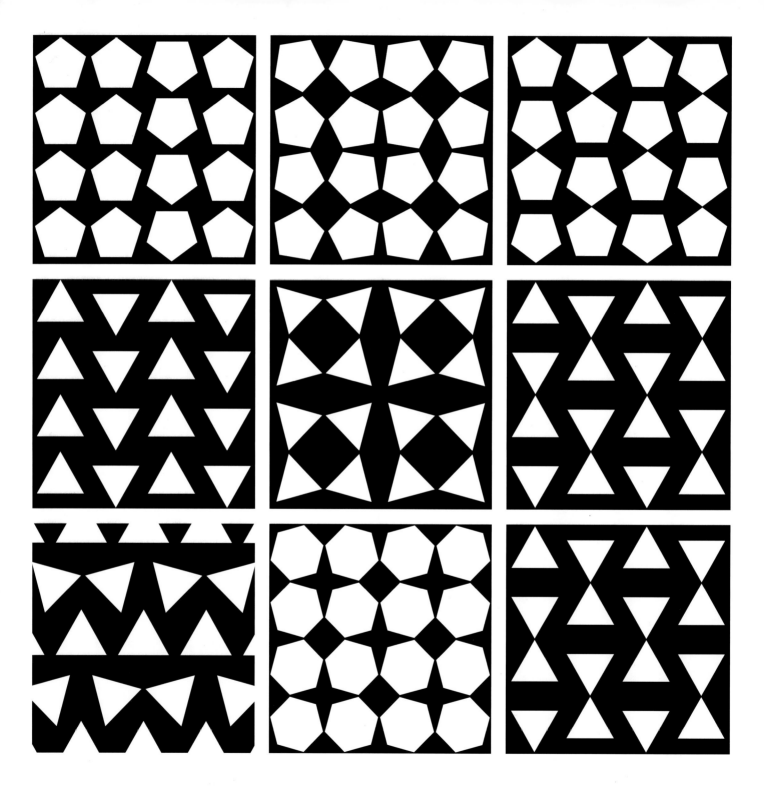

142

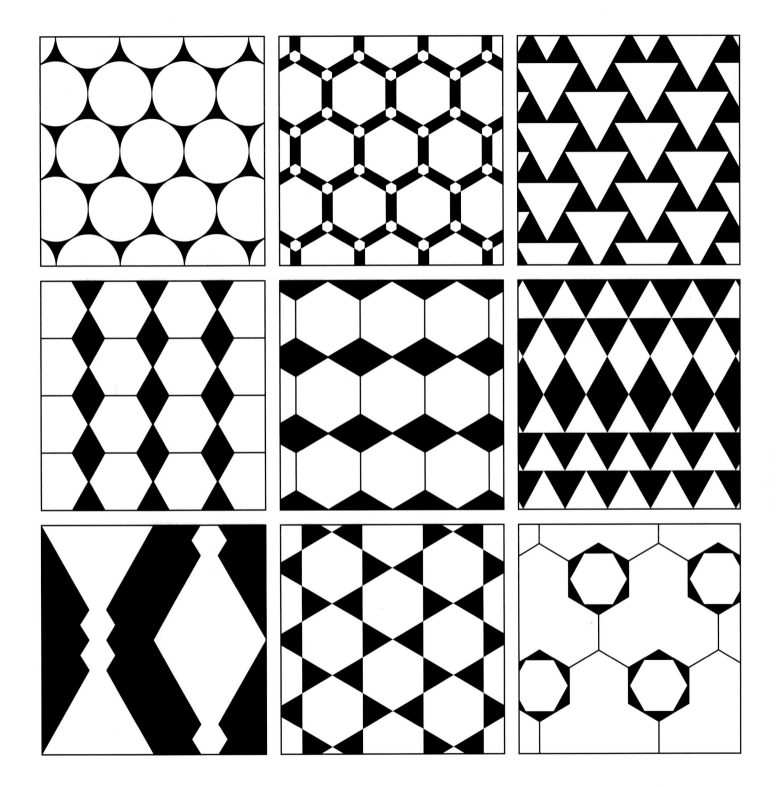

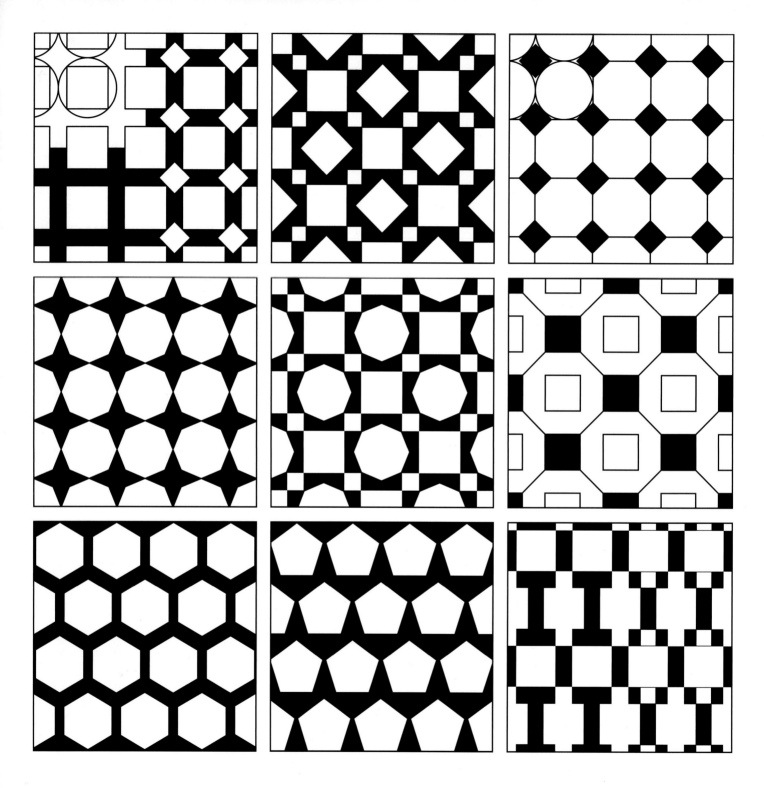

144

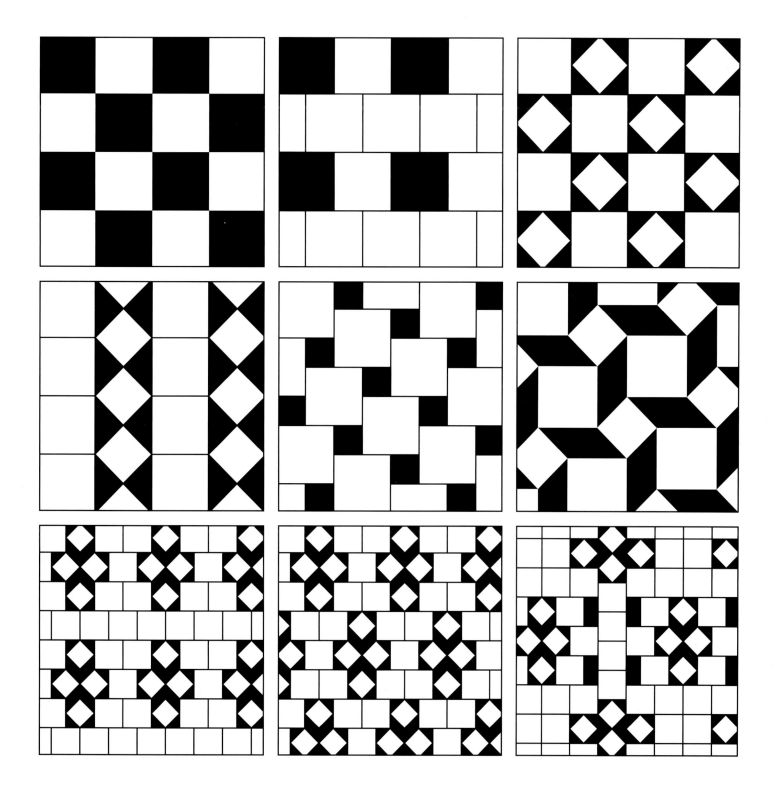

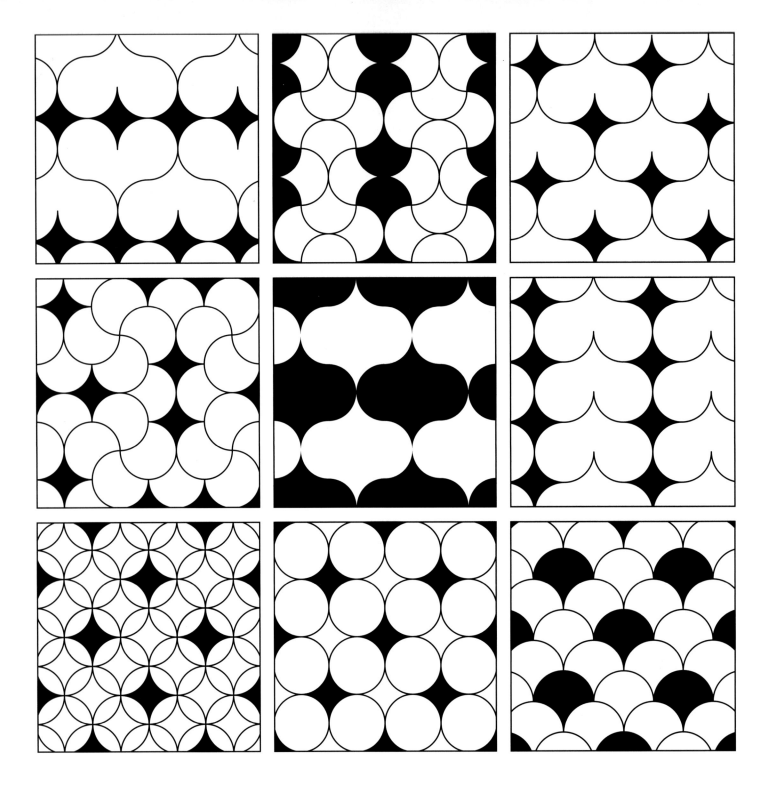

146

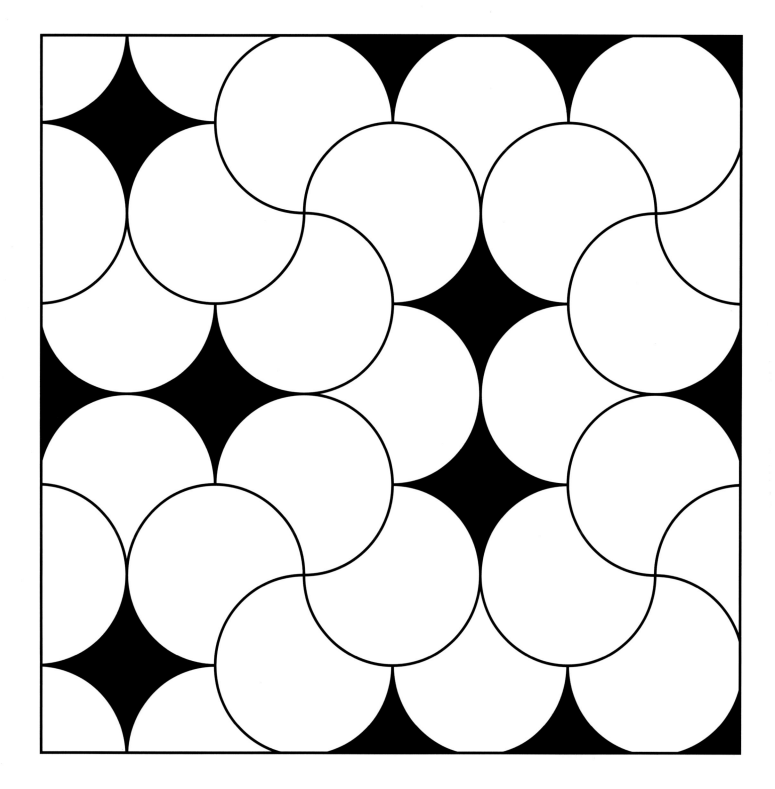

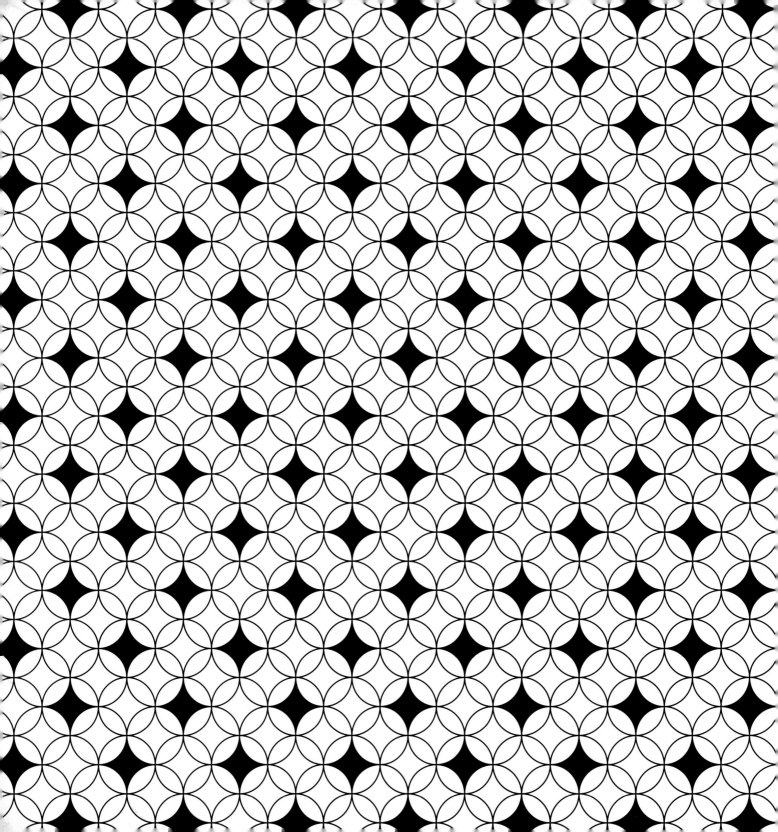

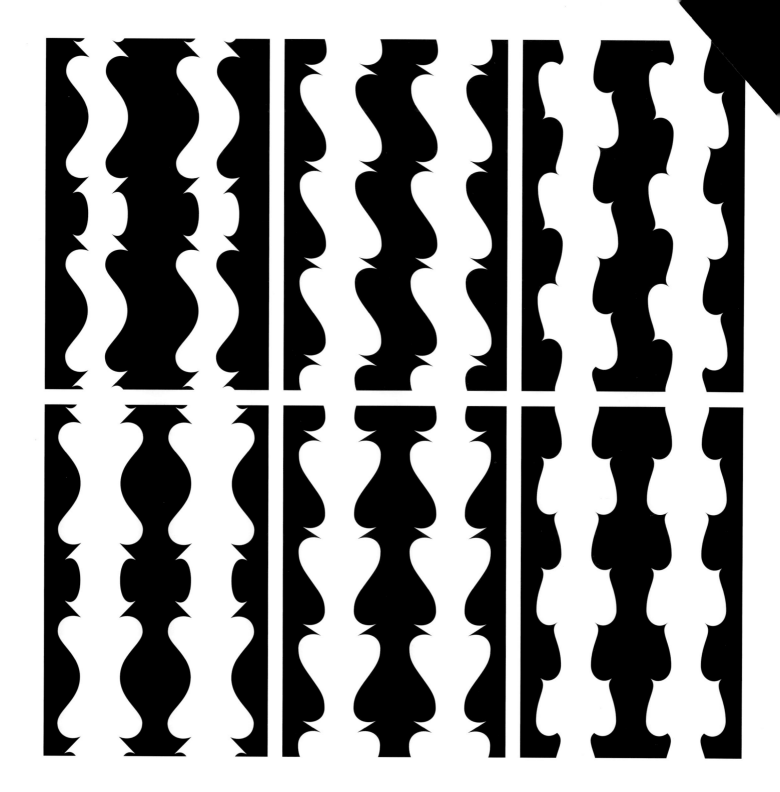

153

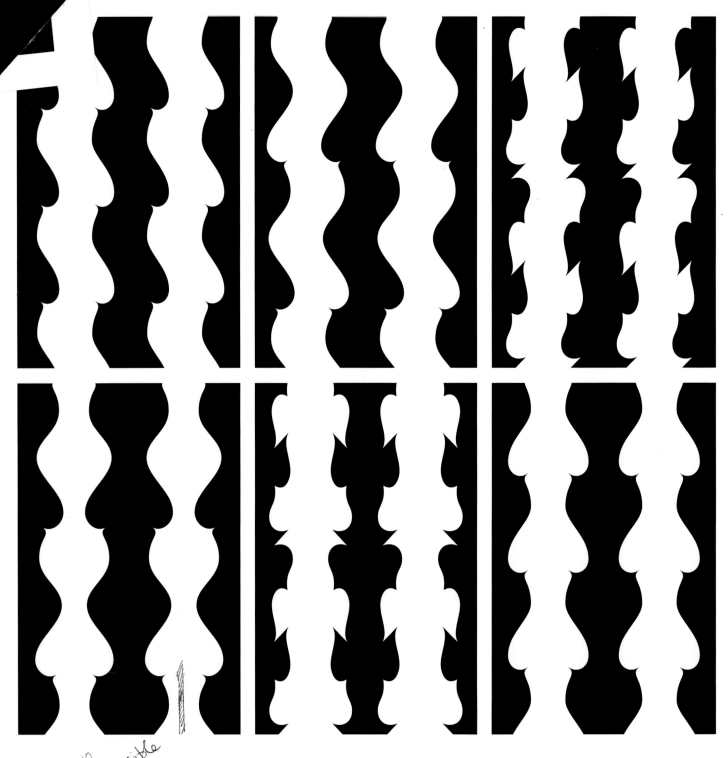

*P Possible

154

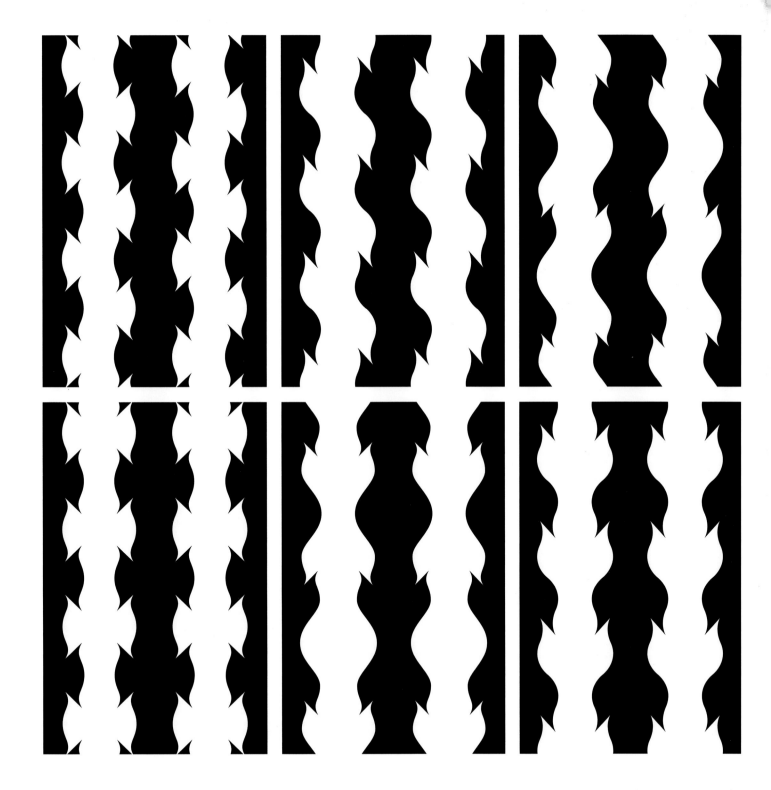

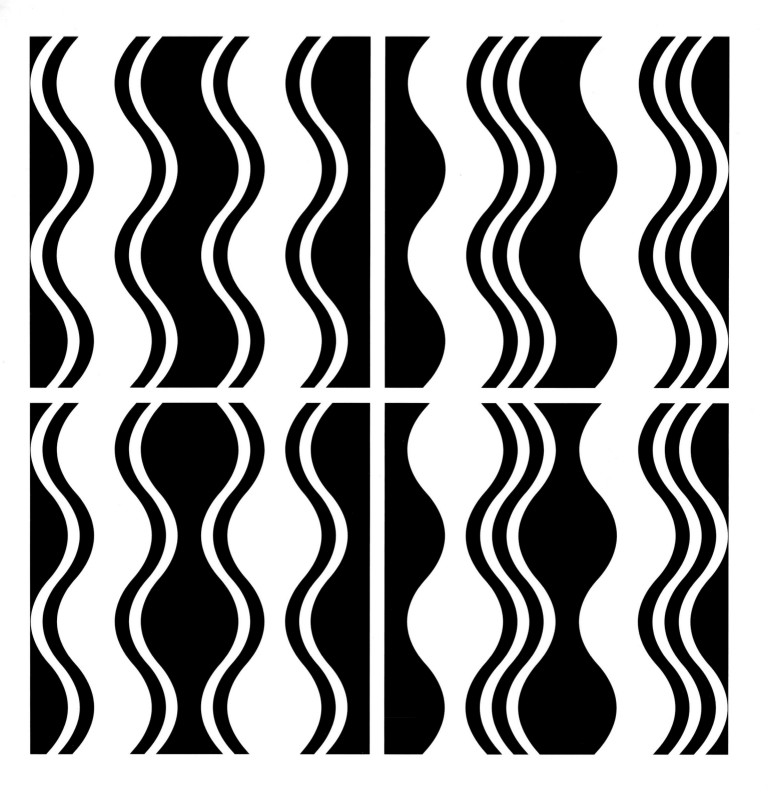

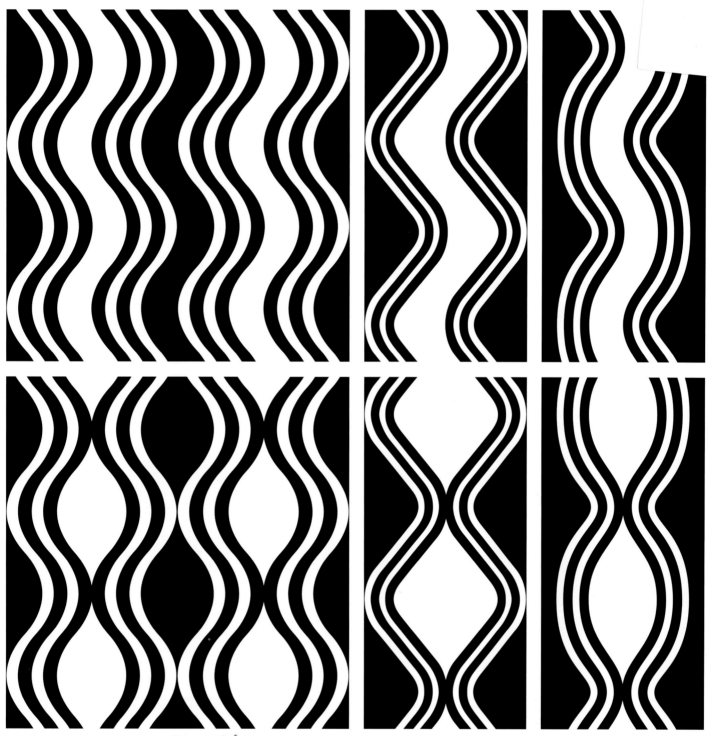

x simplify.

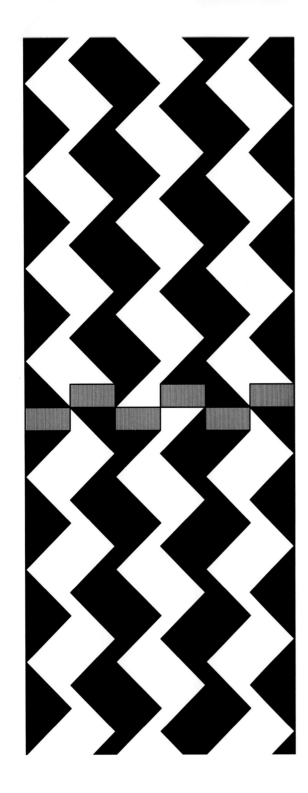
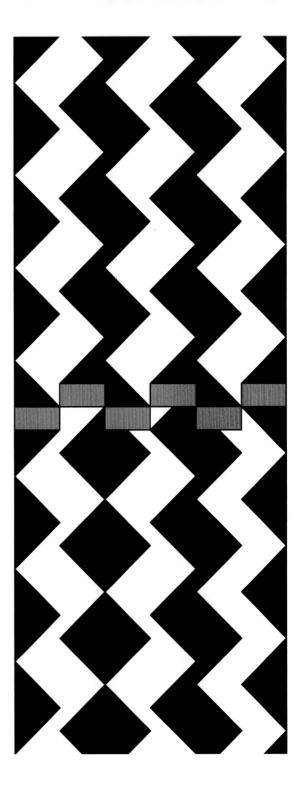

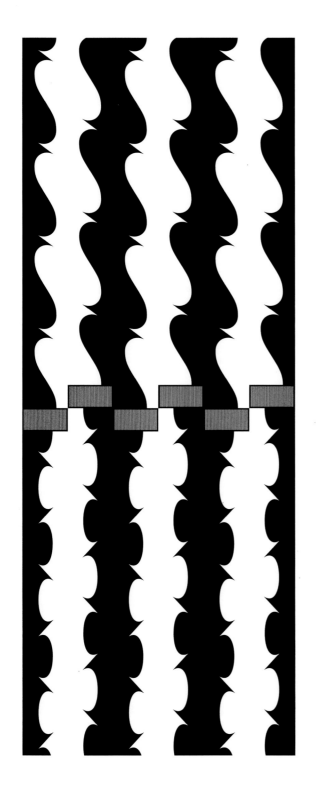

159

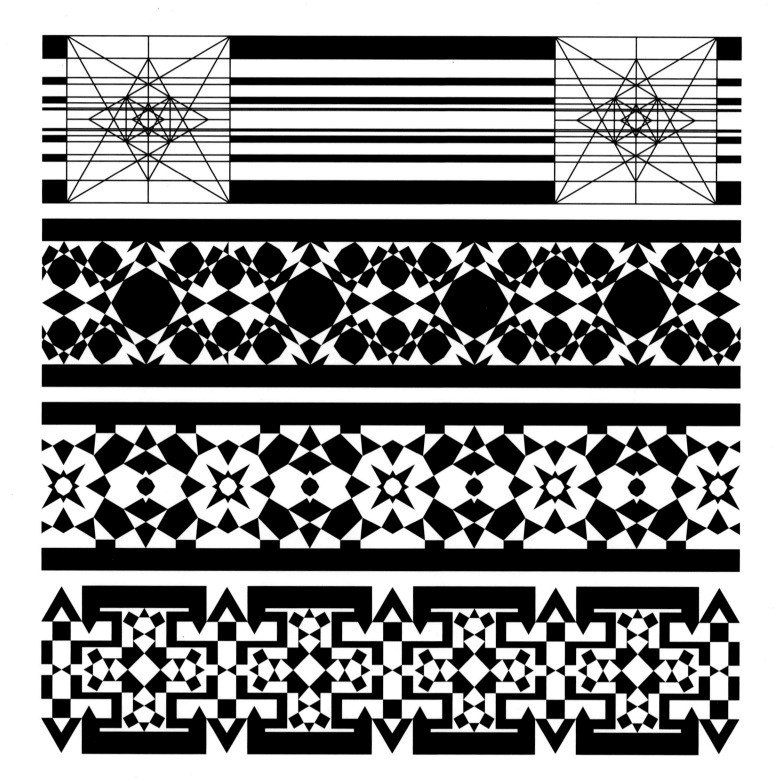

163

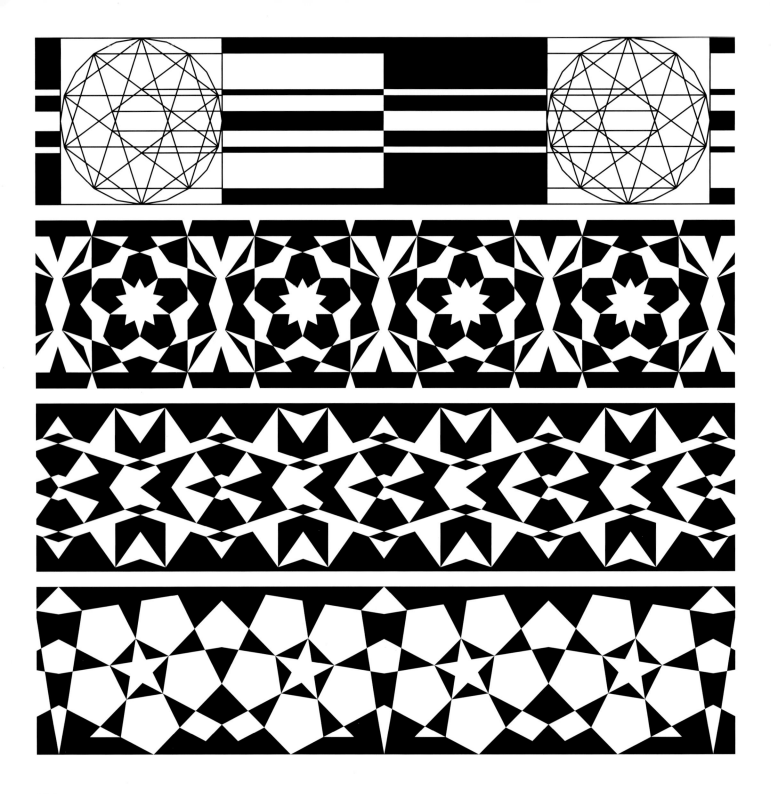

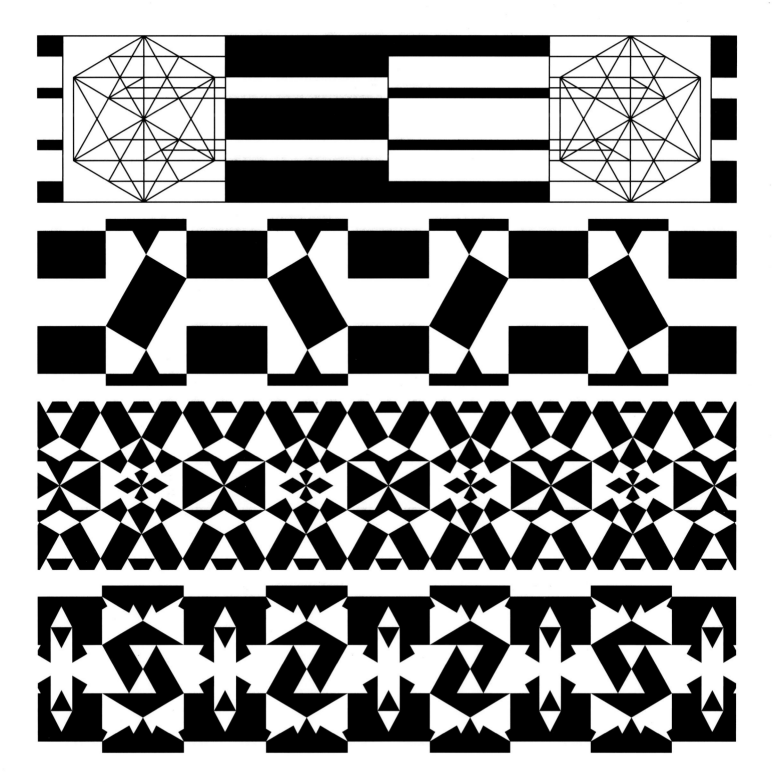

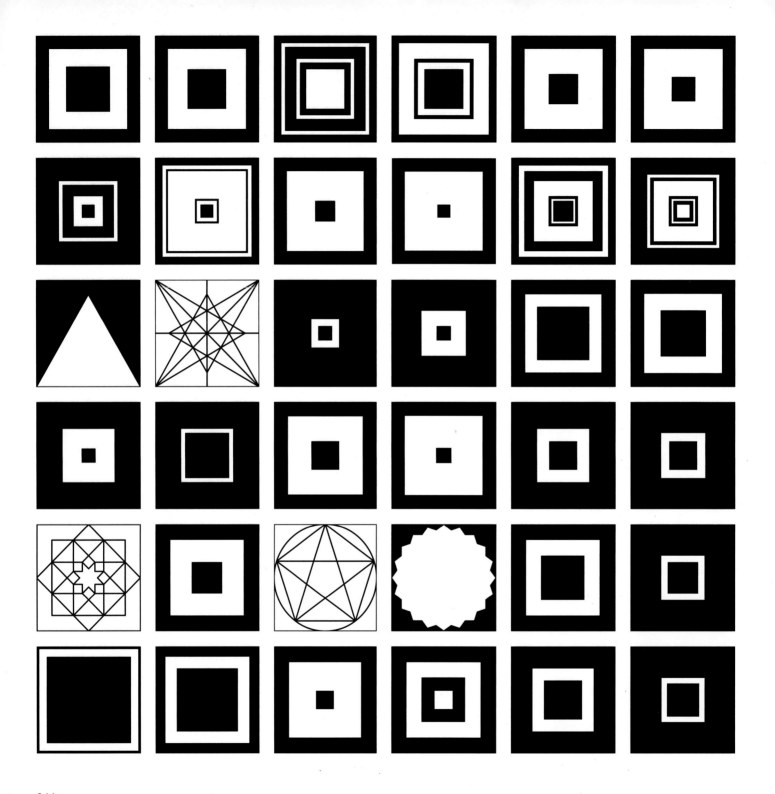

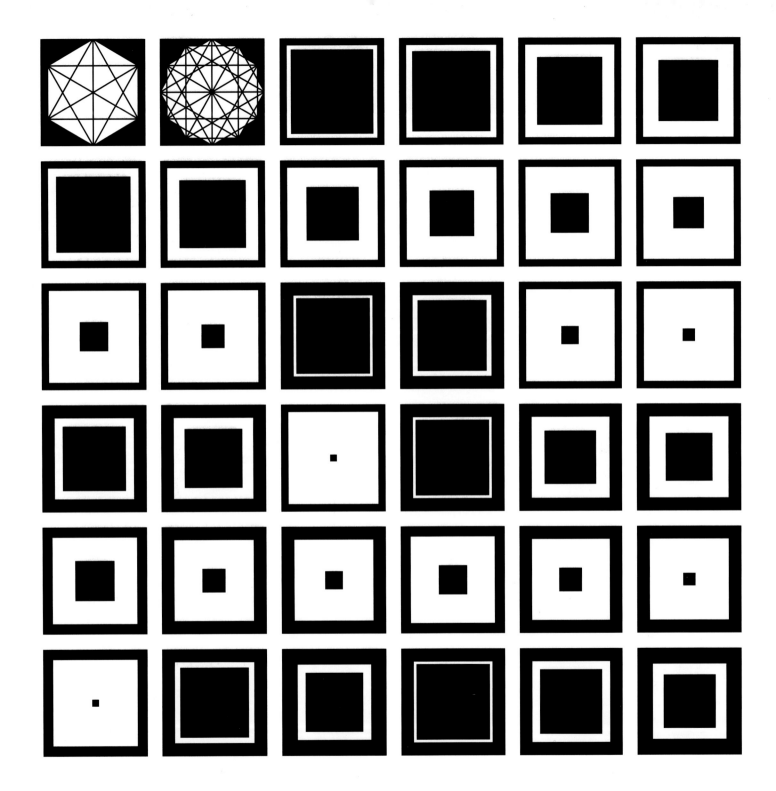

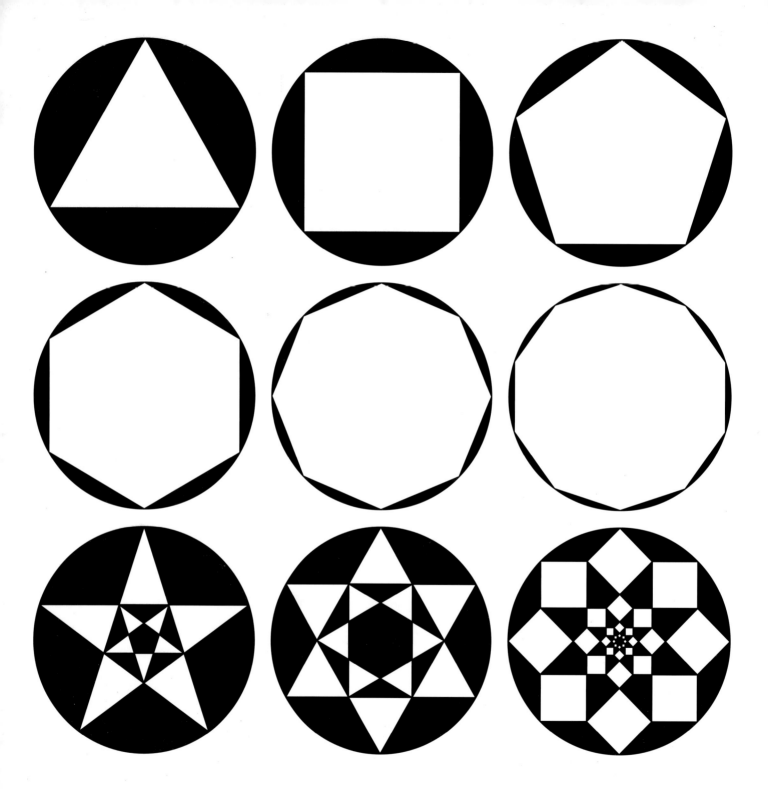